D1257762

VISUAL & PERFORMING ARTS

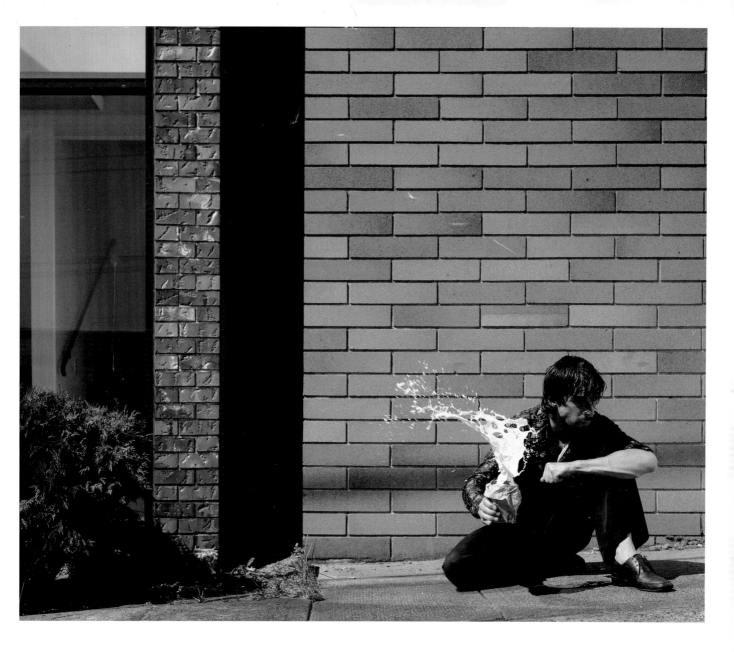

MODERN ARTISTS

First published 2005 by order of the Tate Trustees
by Tate Publishing, a division of Tate Enterprises Ltd,
Millbank, London SW1P 4RG
www.tate.org.uk/publishing
© Tate 2005

All rights reserved. No part of this book may be reprinted
or reproduced or utilised in any form or by any electronic,
mechanical or other means, now known or hereafter
invented, including photocopying and recording, or in any
information storage or retrieval system, without permission
in writing from the publishers.
The moral rights of the author have been asserted.

British Library Cataloguing in Publication Data
A catalogue record for this book is available from the
British Library
ISBN 1 85437 611 x (pbk)
Distributed in the United States and Canada by
Harry N. Abrams, Inc., New York
Library of Congress Cataloging in Publication Data
Library of Congress Control Number: 2005923373
Designed by Nick Bell design
Printed in Singapore

Front cover and previous page:
MILK 1984 (detail of fig.18)
p.4: A SUDDEN GUST OF WIND (AFTER HOKUSAI)
(detail of fig.33)

Measurements of artworks are given in centimetres, height
before width, followed by inches in brackets.
Dimensions of works by Jeff Wall refer to the size of
transparency, not to the outstanding frame or lightbox.

Author's acknowledgements

Thanks very much to Jeff Wall for his time and openness,
and to Adam Harrison and Owen Kydd at the studio. Lewis
Biggs, Mary Richards, Melissa Larner and Katherine Rose at
Tate Publishing made the book happen, so many thanks to
them. Thanks also to Charlotte Mullins for the initial tip and
for being a patient soundboard. And thanks to Eve and
Lucas for all the little things along the way.

Thanks are also due to the people whose interviews with
Jeff Wall, cited below, provided raw material for the book.

Els Barents, 'Typology, Luminescence, Freedom: Selections
from a conversation with Jeff Wall', *Jeff Wall: Transparencies*,
Munich 1986.

Patricia Bickers, 'Wall Pieces', *Art Monthly*, Sept. 1994,
no.179, pp.3–7

Jean-François Chevrier, 'A Painter of Modern Life: An
Interview between Jeff Wall and Jean-François Chevrier',
Jeff Wall: Figures and Places – Selected Works 1978–2000, exh.
cat., Museum für Moderne Kunst, Frankfurt 2001

Robert Enright, 'The Consolations of Plausibility: An
Interview with Jeff Wall', *Border Crossings*, vol.19, no.1, 1999,
pp.38–51

Morgan Falconer, 'Jeff Wall', *contemporary*, no.47/48, 2003,
pp.66–7

Boris Groys, 'Photography and Strategies of the Avant-
Garde: Jeff Wall in Conversation with Boris Groys', *Jeff Wall:
Figures and Places – Selected Works 1978–2000*, exh. cat.,
Museum für Moderne Kunst, Frankfurt 2001

Jan Tumlir, 'The Hole Truth: Jan Tumlir talks with Jeff Wall
about The Flooded Grave', *Artforum*, March 2001, pp. 112–17

JEFF WALL

VISUAL & PERFORMING ARTS

Craig Burnett

Tate Publishing

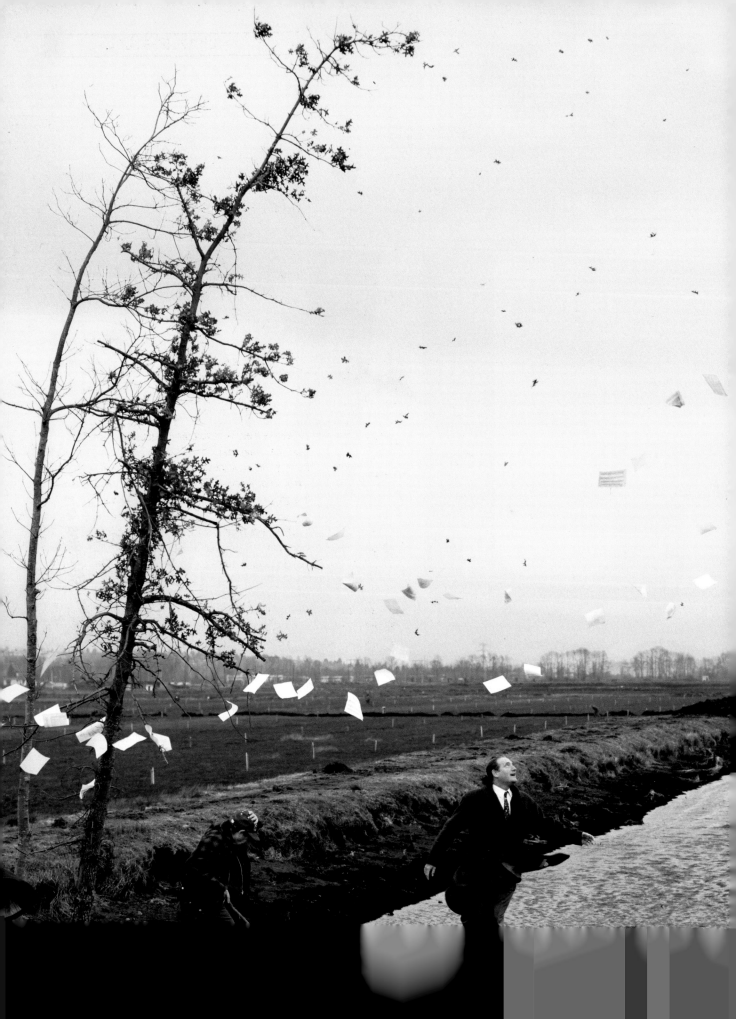

R0407202576

A VENTRILOQUIST AT A BIRTHDAY
PARTY IN OCTOBER 1947 1990 [1]
Transparency in lightbox
229 x 352.5 (90 x 138 3/4)
National Gallery of Canada, Ottawa.
Purchased 1988

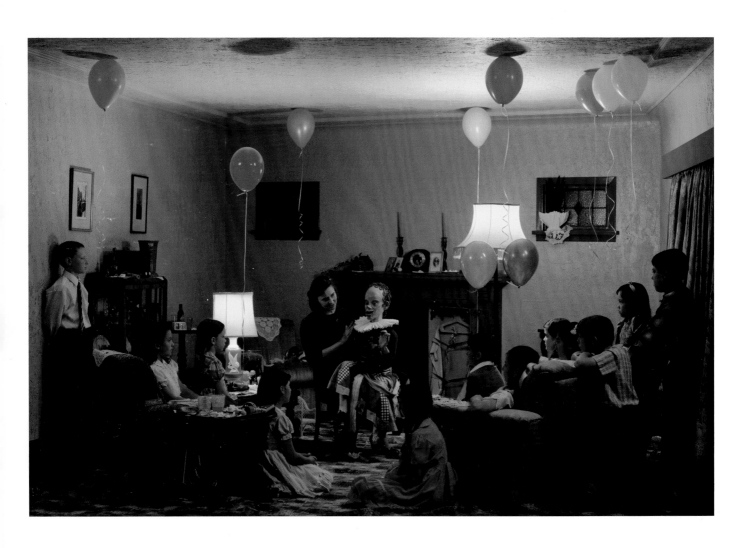

JEFF WALL: LANDSCAPES
Installation view, Norwich Castle
Museum and Art Gallery, 2003 [2]

INTRODUCTION

'Look before you leap' is a common warning sign posted in front of pools and outdoor swimming spots all over North America, and it might be equally useful to put it up near Jeff Wall's photographs. His work is, among other things, about looking closely, about the pleasure of seeing the world in all its sensual intricacy. 'Experience and evaluation', he has said, 'are richer responses than gestures of understanding or interpretation'. So, before leaping into the depths of the picture to salvage a meaning, look closely – most of the pleasure of Wall's work lies on the photograph's sensual surface. But it pays to look again, to examine the details and let them filter into one's experience of the picture.

Wall's *A ventriloquist at a birthday party in October 1947* 1990 (fig.1) is a mid-career photograph, and a characteristic mingling of aesthetic pleasure and evocative detail. In the centre of the picture, a ventriloquist attempts to coax a few words from her heavy-eyed dummy. As in many of Wall's photographs, a speaker is present, but we can only guess what he – or she – has to say. Words, or stories, are often a kind of implicit element in his work, offering some suggestion of an ongoing narrative beyond the moment of the picture. The balloons rise like the suspended disbelief of the children, rapt by the strange spectacle of a doll that matches them in size and yet is clearly old, grubby and a bit grotesque, an image of worn-out experience against their innocence. The mood of the room is warm, comfortable and eerily quiet, and the communal absorption of the children has an unusual intensity. (Why isn't one of them running around or getting bored like a normal child?) This work, which hooks the viewer in with its strange, shadowy beauty, provides an example of how to enjoy a Wall photograph: closely, quietly, in anticipation of change and alert to details. One such detail is the head of the doll, which Wall based partly on Jean-Antoine Houdon's portrait of Voltaire. So who, exactly, is talking? Does the doll express Enlightenment ideals such as reason and progress, does it tell a few infantile jokes, or is it Jeff Wall talking about his own work? Because it is silent, the picture can speak with all these voices, but it is up to the viewer to come up with a script.

THE DESTROYED ROOM 1978 [3]
Transparency in lightbox
159 x 234 (62 5/8 x 92)
National Gallery of Canada, Ottawa.
Purchased 1988

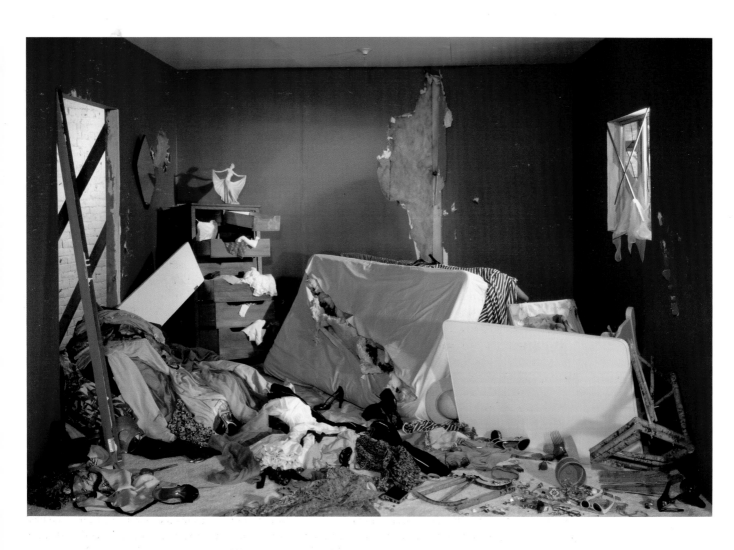

Eugène Delacroix
DEATH OF SARDANAPALUS 1827 [4]
Oil on canvas
392 x 498 (154 ¼ x 196)
Musée National du Louvre, Paris

1

THE PAINTER OF MODERN LIFE

He has everywhere sought after the fugitive, fleeting beauty of present-day life, the distinguishing character of that quality which, with the readers' kind permission, we have called 'modernity'.
Charles Baudelaire, *The Painter of Modern Life* (1863)

Long bus rides seldom stimulate bright ideas, but it was on a bus, while gazing out of the window, that Jeff Wall had the brainwave that launched his artistic career. Travelling through France after his first visit to the Prado Museum, Madrid, his head abuzz with paintings by Spanish masters Diego Velázquez and Francisco Goya, he became increasingly captivated by a structure so commonplace that it is almost invisible: the illuminated advertisement. 'I kept seeing these things at the bus terminals', recounts Wall, 'and it just clicked that those back-lit pictures might be a way of doing photography that would somehow connect those elements of scale and the body that were important to Donald Judd and Barnett Newman and Jackson Pollock, as well as Velázquez, Goya, Titian or Manet'. Wall's memories of Old Master paintings collided with these metallic structures, reminiscent of modernist abstraction, structures that glowed, moreover, with people going about the business of everyday life. Through a garish, utilitarian device invented by the advertising industry, he envisaged a new kind of large-scale photography that would combine Old Master ambition with the fleeting, sometimes vulgar beauty of modernity. Contemporary art would never look the same.

The year was 1977, and Wall was a lecturer in fine art at Simon Fraser University, Vancouver, Canada. Post-Conceptualism and Minimalism, the colourless last hurrah of the avant-garde, were the dominant modes in the art world. Photography had been rising in prominence over the past decade, and American photographers such as Diane Arbus, William Eggleston and Ansel Adams had a strong presence in both the museums and the market. Meanwhile, Ed Ruscha was playing with the conceptual possibilities of photography, and in Germany, Bernd and Hilla Becher were taking a hard-nosed approach to documenting the post-war landscape. But for reasons both technical and aesthetic, photographs were usually printed and exhibited on a relatively small scale, and the medium's ethos remained chiefly documentary. Wall remembers 'being in a kind of crisis at the time, wondering what I would do'. But as he stared out of his bus window somewhere in the middle of France, all the elements coalesced. A light-box, with its somatic scale and zips of forceful colour, brings to mind an abstract painting by Barnett Newman, while colourful depictions of everyday life on a pictorial scale evoke the figurative tradition of Western art. Thus, in a brash by-product of modern capitalism, Wall found a way to bring together the three things that interested him as an artist and student of art history: the experimental legacy of the avant-garde, the tradition of Western figurative painting and the everyday debris of contemporary life.

Wall was born in September 1946 in Vancouver, where he still lives and works. Art was his *raison d'etre* from his early teens. In those formative years, he was devouring comics, Dostoyevsky, art history and art magazines in equal measure, and he visited local galleries with his mother. His father, a medical doctor (he plays the doctor in Wall's work *A Woman and her Doctor* 1980–1 [fig.5]), adapted the garden shed for him, turning it into a studio, where he spent many hours painting, and when he was about fourteen he sent some drawings to *The New Yorker* (his only regret is that he threw away the rejection

A WOMAN AND HER DOCTOR 1980–1
[5]
Transparency in lightbox
100.5 x 155.5 (39 ½ x 64 ¼)
Edition of 3

letters). In 1962, he had his first direct encounter with modern art at the Seattle World's Fair, where an exhibition of Modern American Art featured everyone from Ben Shahn to Jasper Johns. But in particular he remembers being 'blown away by the scale of Jackson Pollock and Franz Kline', and going home to paint a Motherwell-inspired painting that filled the garden shed.

Despite his artistic ambitions, Wall decided not to attend art school. Instead – as befits a self-described 'bookworm' – he studied art history at the University of British Columbia. After taking an MA at the university, he undertook graduate studies at the Courtauld Institute, London and these three years at the world-renowned institution of art history were exceptionally fruitful for the fledgling artist. 'I feel I had a very good education at the Courtauld', reflects Wall,

even though I almost never went to a class, met an advisor or had a conversation with another student. The School just let me drift along, thinking about whatever I wanted ... It was a way for me to reflect on my instinctive admiration for beautiful works of art, something that I had felt as a child in Vancouver, where there were so few actual works to be seen. Art history helps me to discover objective things in my own intensely pleasurable experiences.

Throughout the early to mid-1970s, Wall was finding many of his 'intensely pleasurable experiences' in film rather than contemporary art, especially in the work of European directors Jean Eustache, Ingmar Bergman, Michelangelo Antonioni and Rainer Werner Fassbinder. He was given the opportunity to examine these films with unusual intensity when, after his London sojourn, he started working at an independent cinema in Vancouver, where it was his responsibility to check the physical condition of the prints. As he examined them, frame by frame, he realised that the directors he admired were making – in collaboration with cinematographers – work that often surpassed the ambition, seriousness and beauty of contemporary art. 'That's when I started to appreciate film as photography', comments Wall, 'and I started to think that this was akin to painting and to writing poetry'. This insight prompted him to toy with the idea of becoming a filmmaker for a couple of years, but after some unsuccessful scripts and an unfinished film project (with fellow Vancouverite artists Ian Wallace and Rodney Graham), he used his academic credentials to secure a job as a lecturer.

Wall's day job did not diminish his ambition to be an artist. Fortuitously, his serious dabbling in film led to an idea that could complement his on-the-bus epiphany. A photograph, he realised, need not capture a 'decisive moment' as promulgated by Henri Cartier-Bresson; nor does it have to be a document of an existing place or thing. Like a film director, he could collaborate with technicians and actors to create fiction or poetry rather than documentary. Wall now calls this method 'cinematography', and although he also practices 'documentary' or 'straight' photography, it was his 'cinematographic' method that first attracted attention to his work. (Interestingly, Cindy Sherman started a similar project almost simultaneously in New York, though their approaches would diverge significantly over the next thirty years.)

Wall soon adopted the expression 'painting of modern life' to characterise his aims as an artist. The nineteenth-century poet and art critic Charles Baudelaire coined the phrase 'The Painter of Modern Life' for the title of his glowing essay on Constantin Guys, the nineteenth-century artist and illustrator who has since become little more than a footnote in

THE BRIDGE 1980, printed in 1985 [6]
Transparency in lightbox
60.5 x 228.6 (23 7/8 x 90)
Edition of 3

the history of French art. But the expression has stuck to the life and work of Edouard Manet, the so-called father of modern art and a painter whose life and oeuvre stirred up some of the initial impulses of the avant-garde even though his ambitions were elsewhere. Manet wanted to match the brilliance of his heroes Velázquez and Goya rather than be a hotheaded revolutionary, yet he couldn't help but upset the bourgeoisie: he painted with breathtaking élan, his works such as *Olympia* and *Déjeuner sur l'herbe* were considered scandalous and the Salon rejected much of his work. When he died, aged only fifty-one he had become a fulcrum of Old Master brilliance and modern attitude.

By looking back at the project initiated by Manet, Wall wanted to pick up an idea that much of the mainstream art world had abandoned after modernism. 'This notion of the painting of modern life is so simple that you barely need to emphasise it', comments Wall:

It was a direction for modern art that was superseded by other directions, that is, by abstraction and by strands emerging from Duchamp. Those were perfectly valid and important, but I remain interested in the picture-making project. It has a long history in the West, an inexhaustible quality, so the idea of the painting of modern life was really just a way of keeping my mind focused on that alternative.

Tellingly, when Wall made *The Destroyed Room* 1978 (fig.3), his first light-box, he turned to Eugène Delacroix's *Death of Sardanapalus* 1827 (fig.4) for a kind of template. Delacroix was amongst Baudelaire's heroes and the subject of his most effusive essay, not to mention one of the first artists to use photography as an artistic tool. *Death of Sardanapalus*, which is derived from Byron's arch-Romantic play, depicts a moment of frenzied and erotic violence. The Assyrian

King Sardanapalus, aware that he is about to be defeated and plundered, lounges impassively while his eunuchs obliterate all his possessions, including wives and concubines, in an orgy of destruction intended to deprive his enemies of his immense wealth. Wilful, irrational and clammily narcissistic, the mood of Sardanapalus's chamber is shared by Wall's *The Destroyed Room*. We seem to be witnesses to the aftermath of violence prompted by a psychic disturbance, perhaps self-inflicted violence, vengeance or abuse, and the room bears the scars of self-abasement. The walls are blood red and the pink fibreglass that is visible where it is torn looks like exposed, fatty flesh; the bed is gashed and the contents of the drawers overflow like a disembowelment. Standing above all the destruction, in the position of Delacroix's bearded king, a statuette of a dancer rises like a bird.

The figurine and king act, in some ways, as surrogates for each artist. Both Wall and Delacroix are at a remove from the turmoil and violence they depict; they organise and witness the destruction rather than letting it overflow from their souls. Wall's process is also self-referential: on the right, the studio is visible (which matches a window and a glimpse of the conflagration outside in *Sardanapalus*), as are the boards that hold up the structure, which was constructed like a film set. On the right, a beam of light comes through the window, outside the frame of the photograph, to illuminate the dancer, who lifts her skirt in elegant defiance of the chaos beneath her. We might contrast these two pictures with the stormy brilliance of a painting by Jackson Pollock, the Abstraction Expressionist whose turbulent life helped him become an emblem of the artist as Romantic hero. Pollock expressed himself with drips of paint that are as heartfelt as the knife about to plunge into

MOVIE AUDIENCE 1979 [7]
7 transparencies in 3 lightboxes
Each 101.6 x 101.6 (40 x 40)
Edition of 2

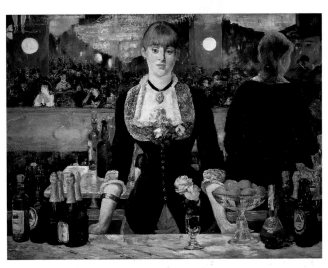

Edouard Manet
A BAR AT THE FOLIES-BERGÈRE 1882 [8]
Oil on canvas
96 x 130 (37 3/4 x 51 1/8)
Courtauld Institute Gallery, London

the bosom of one of Sardanapalus's concubines. Despite embodying the Baroque Romanticism of his age, Delacroix claimed to be a neo-classicist, preferring Mozart's serene control over Beethoven's impassioned experimentation, Poussin's order above the ebullience of Rubens. Yet these caricatured categories of neo-classical calm and Baroque excess are difficult to apply in an exacting and straightforward way. Many of the paintings of Delacroix's rival, Ingres, for instance, were laced with exotic figures and locales, the very essence of Romanticism, despite their neo-classical sheen and rigidity. But the point is this: when we look at *The Destroyed Room*, we should look at it as a self-contained object rather than a register of the artist's mind. Neither Delacroix nor Wall express preternatural feelings so that the spectator can vicariously experience a heightened emotion.

Movie Audience 1979 (fig.7) offers a model of how to experience a Jeff Wall picture. The figures look up at a cinema screen, enraptured by the image that illuminates their faces. They are absorbed in the activity of looking, smiling gently as a result of their aesthetic experience. They glow as if illuminated by the light of some revelation, though this cinema-screen radiance is the everyday flicker of contemporary life. At one level, Wall shows his reverence for cinema, but on another, *Movie Audience* speaks to us of an art that is not necessarily about the internal life of its creator, but about the act of looking attentively. In a gallery, *Movie Audience* hangs above eye level, so that when a viewer looks at the work, his or her action will mimic the action of the person depicted in the photograph, and the glow cast by Wall's back-lit photograph will match the glow on the faces of his depicted audience. Both Wall's audiences – the one he portrays and the one looking at his

picture – gaze up, and this creates an erotic triangle of relationships between artist, work and audience, a network of curiosity and desire of which the viewer becomes a part.

This triangular structure can also be felt in one of Wall's best early photographs, *Picture for Women* 1979 (fig.9), a work that Wall has called 'a classroom lesson on the mechanisms of the erotic'. While at the Courtauld Institute, he became familiar with a painting in its collection, Manet's late masterpiece, *A Bar at the Folies-Bergère* 1882 (fig.8). He has described *Picture for Women* as a remake of this painting, in the same way as a movie might be a remake of an older one – an update that uses new technology and a slightly inflected take on a theme. Unlike the Manet painting, set in a boisterous bar, *Picture for Women* takes place in an ordered studio (which is, in fact, a classroom) and is static. A man (the artist) and a woman (his model) are reflected in a mirror (as they are in Manet's painting), and the camera is like a third figure, a mechanical Cyclops with an unappeasable eye, which acts as a kind of all-seeing chaperone to the couple. The woman is both the subject of and the audience for the picture, since she looks back at herself, and the triangular structure between the artist, audience and work exists within the camera. If one looks closely at the release cable that travels from the artist's left hand to the camera, one sees that its movement is blurred, like a brushstroke. The snap of the shutter creates a kind of irretrievable moment, partly beyond the artist's control, and in this blur of cable is an uncontrollable element that distinguishes photography from painting. The artist experiences a loss of control when he releases the shutter, and at that moment he enacts an imaginary, shared desire for objectivity.

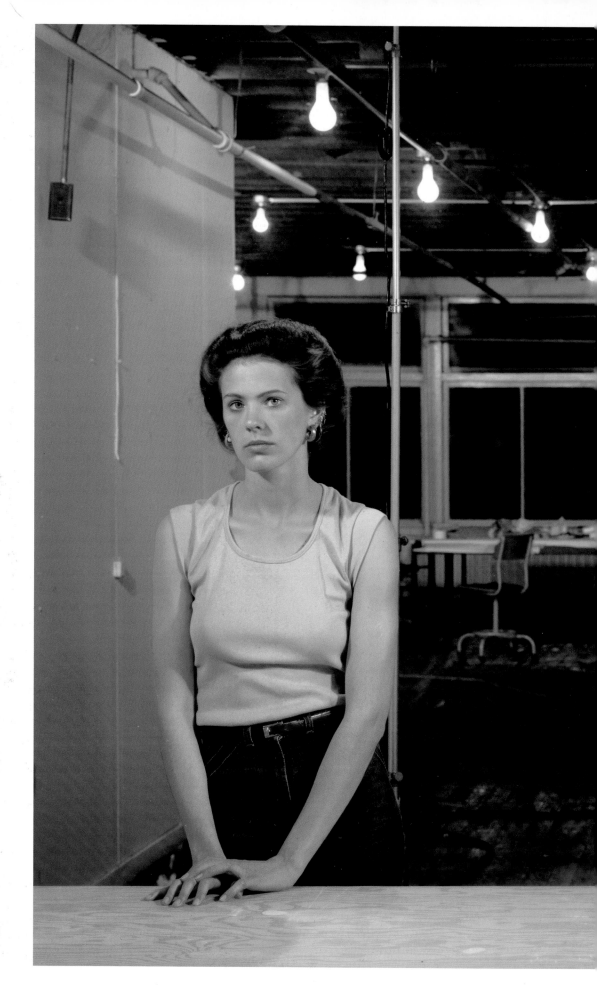

PICTURE FOR WOMEN 1979 [9]
Transparency in lightbox
142.5 x 204.5 (56 x 80 ½)
Collection of the artist

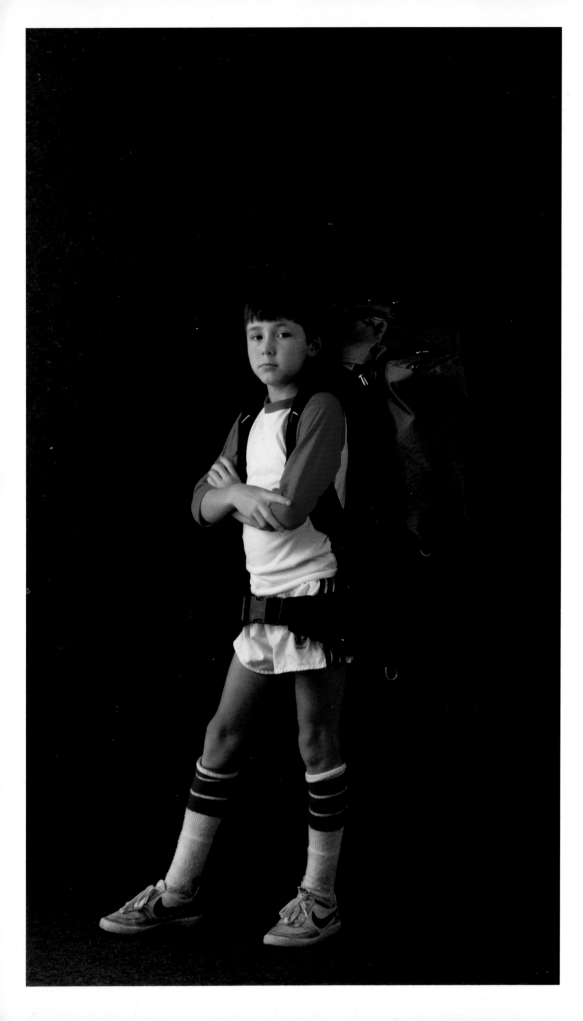

BACKPACK 1981–2 [10]
Transparency in lightbox
213 x 118 (83 7/8 x 46 1/2)
Vancouver Art Gallery Acquisition
Fund

Edouard Manet
THE PIPER 1866 [11]
Oil on canvas
161 x 97 (63 3/8 x 38 1/4)
Musée d'Orsay, Paris

Backpack 1981–2 (fig.10) plays with ideas of control and subjectivity through the full-length portrait, a genre familiar to Manet. The subject, an average eleven-year-old boy, faces the camera inexpressively. The title, unexpectedly, refers to what he wears rather than who he is, and indeed he looks as if he could be a model in an advertisement. The image depicts the fashions of a specific time and place: the Nike shoes and Adidas shorts worn by the boy represent a kind of uniform, a uniform dictated by the forces of the market and a local culture rather than by an institution or individual desire. The backpack hints at the culture of Vancouver, a city as wrapped up in outdoors activities as nineteenth-century Paris was famous for its vibrancy and decadence. The boy's identity, in other words, is wrapped up in the culture of his day. Manet's *The Piper* 1866 (fig.11) depicts a similarly posed boy of about the same age hidden behind the accoutrements of his profession and contemporary fashions. Moreover, both pictures exist in a flattened, unknown space. So when we look at Manet's portrait, we see nineteenth-century ideas as much as we see a specific person in a setting. The poignancy of both portraits emerges from how the identity of a boy – fleshy, mortal and unique – is largely defined by the contingencies of history.

Social and historical forces loom like a capitalist apocalypse over the bucolic innocence of *Steves Farm, Steveston* 1980 (fig.12). (This landscape, along with *The Bridge* 1980 (fig.6) and *The Jewish Cemetery* 1980, are examples of 'documentary' photography. *The Bridge* was Wall's first work in this genre.)

A seemingly ageless pastoral landscape, with a wandering stream and grazing horses and cows, collides with a strip of mass housing. And yet there is nothing natural about *Steves Farm*: the area used to be a wilderness in a river delta. The pastoral is an artistic convention and an ancient ideal as artificial as the housing piling up on the horizon. Barely visible in the centre of the picture, a man walks along the curved road that allows Wall to fuse both landscapes into one vision. Like the 'painter of modern life', he can observe a confluence of old ideas, natural rhythms and encroaching modernity. Wall, let's recall, is a photographer, not a painter. Baudelaire related the 'shock' of modernity to the instantaneity of photography, the loss of control suggested by the release of the shutter. The 'painter of modern life' ignores and redeems nothing: not the sentimental horses nor the tawdry mass housing. And in that openness, the vast moment when Wall's shutter clicks, we find the 'fugitive, fleeting beauty of present-day life'.

STEVES FARM, STEVESTON 1980,
printed in 1985 [12]
Transparency in lightbox
58 x 228.6 (22 7/8 x 90)
Edition of 3

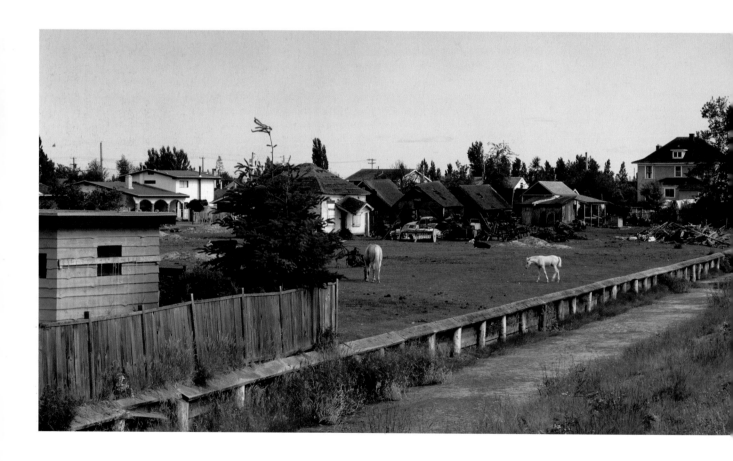

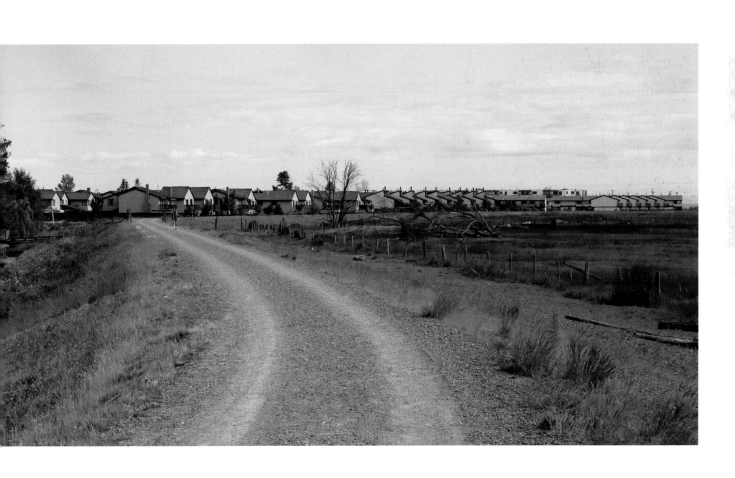

The magic-hour light as well as the gritty street setting of *Mimic* marked a change from the self-conscious remakes or variations on nineteenth-century painting that characterised much of Wall's earliest photography. Yet there are also important continuities: he wanted to blend the 'hard-lit, documentary look' of 1970s cinema with the scale and clarity of Old Master painting. To achieve the sharpness of *Mimic*, Wall used a large-format 8 x 10 camera, in contrast to the 35mm used by both filmmakers and street photographers.

Mimic also took Wall out of the studio to face the more unpredictable conditions of street photography. Practised by Garry Winogrand, Robert Frank and others, this was one of the dominant movements in the world of photography throughout the post-war period. Feeling that it was aesthetically limited, however, Wall invented what he calls his 'cinematographic' mode of photography, in which he can recreate something he has witnessed with the look and feel of documentary photography, but as a fiction, using the techniques of a filmmaker. Some level of believability is essential to the success of *Mimic* and other pictures of this period; the unfolding drama and gestures automatically bring to mind a commonplace event on the street. Thus an everyday event is treated monumentally, with all the pathos and pictorial force of an Old Master painting.

In 1985, Wall talked about the 'micro-gesture' in *Mimic* as a 'mechanical, automatic or impulsive' urge that is a result of 'stress, stimulation or provocation', an example of 'unreflected social action' that 'involves a regression of the individual, an accumulating conformism'. He wanted to make an 'image which shows the inner contradictions of this figure, its socially determined quality, and also its otherness to itself'. So although the situation depicted emerged from an actual experience, and the action of the white man is clearly abusive, Wall wished to show how it was a generalised, social issue rather than the act of a nefarious individual.

An idea worth considering when looking at *Mimic* is that of 'mimetic desire'. René Girard, a French-American thinker whose theories have been highly important to Wall's research, describes 'mimetic desire' as a fundamental, defining characteristic of human life. Desire, according to Girard, is essentially imitative: we want what other people want because another person's desire makes an object desirable, and this process accelerates the desire between rivals. Mimetic desire divides because it creates a conflict over the same object (in the situation depicted

in *Mimic* this may be respect or affluence), but it also creates a symmetrical relationship between antagonists, so that their mutual, competing desire creates a situation in which they begin to resemble one another. Thus the gesture of the white man, possibly provoked by a flash of unconscious 'mimetic desire', causes him to resemble the Asian man in a direct, physical way.

CRAIG BURNETT: The event in *Mimic* is something you witnessed.

JEFF WALL: *Yes, I saw that happen, and that's when I realised that I could do this sort of thing, whereas before, I was working in the studio. I'd only been making my transparencies for a few years, so I hadn't done that many pictures. I had done my landscapes, but when I saw this thing in the street I realised I could do street photography, which was a norm in photography at the time.*

CB: What interested you about the gesture?

JW: *The gesture was so small. I was interested in the mimesis, the physical mimesis. The white man was copying the Asian's body. Mimesis is one of the original gestures of art. So there was a sense in which emphasising the mimesis could take away from the simple evildoing, which was interesting but not necessarily the most interesting thing about the picture. That made the 'villain' into a creator of something even though he was doing something bad. I like that play because you could interpret the picture politically: good guy, bad guy, non-white guy, white guy. But that political meaning doesn't really interest me, so I complicated the relationship.*

CB: And the white guy is probably mimicking someone else's behaviour.

JW: *Yes, probably, so the mimesis just spreads.*

CB: The mimesis extends to the setting. The buildings on the right mirror the buildings across the road.

JW: *Yes, that's nice. I needed a place to do it, and when I'm looking for a location – and I still do this now – I go back to the original place that I've seen, and think, 'Well, maybe I can do the photograph here.' But usually it doesn't have the formal character that I want, so I free myself – I free myself from the place. I don't really know what I'm looking for until I find it. That picture needed the plunging perspective, and I like the hill rising up in the back.*

CB: The reflective windows and the plunging perspective act like puns, it seems to me, about the nature of making pictures. The parking sign also seems like a pun about different kinds of picture making and about the rules and prohibitions in a civic society.

MIMIC 1982 [13]
Transparency in lightbox
198 x 228.6 (78 x 90)
Ydessa Hendeles Art Foundation,
Toronto

JW: *I don't see them as puns, but as formal properties. I don't think of them as comments, but as physical parts of the picture. The sign was just there. I could have taken it out, I suppose, but I didn't see a purpose in doing so. I liked the fact that there was no writing on it. Writing is distracting and you have to keep reading it over and over again. The sign is a visual language. If I'd really hated it, I would have moved to another place or moved down the street so that the sign was behind me. The prohibition is interesting because the city is full of regulations.*

OUTBURST 1989 [14]
Transparency in lightbox
229 X 312 (90 1/8 X 122 7/8)
Vancouver Art Gallery Acquisition
Fund

BAD GOODS 1984 [15]
Transparency in lightbox
229 x 347 (90 1/8 x 136 5/8)
Vancouver Art Gallery Acquisition
Fund

CONFLICT AND DIALOGUE (1984–9)

All modern thought is falsified by a mystique of transgression, which it falls back into even when it is trying to escape.
René Girard, *Things Hidden Since the Foundation of the World* (1978)

During the mid-1980s, when Jeff Wall began to emerge on the international art scene (he had his first solo show, held at the Institute of Contemporary Arts, London, in 1984), upheaval marked both culture and the economy. While Jeff Koons suspended a basketball in a glass case as if it were a precious relic, Barbara Kruger reclaimed commercial imagery to make sardonic poster-like images that satirised widespread conspicuous consumption. Both were manifestations of a 1980s ethos that delivered carnival and protest in equal measure. In Europe and the USA, neo-Expressionistic painters such as Anselm Kiefer, Julian Schnabel, David Salle and Georg Baselitz, to name a few, dominated a hot art market. The humanities, including universities, art schools and art magazines, were gripped by 'theory', a bouillabaisse of mostly French philosophy, especially post-structuralism, that reduced discussion about art to discussions about ideas. In some ways these intentions were laudable: in an age that tended to glorify 'the deal', many artists and critics tried to create a model of the creation and reception of art that would free it from being just another commodity. At its worst, however, the 'New Left' politics of the time created a haranguing, sanctimonious atmosphere in which beauty and pleasure became scapegoats. As a lecturer and artist, Wall never found the over-emphasis on theory oppressive, exactly, but he did think it led to a lot of 'pseudo-Conceptual, political art that isn't very interesting'.

Amid all this, a potential conundrum lurked in Wall's project to be a 'painter of modern life'. Since Duchamp, figurative art, and especially realist painting, has been associated with anti-modernism, conservative politics and a return to tradition; conversely, post-Conceptual art – the art of the fragment and the readymade – was said to carry the liberating banner of the avant-garde. The post-Conceptual ethos demanded that art test and transgress its own conventions. Recently, the link between rebellion and authenticity have become so mainstream that even Homer Simpson, that emblem of everything bovine and reactionary, could invoke the avant-garde formula to defend his actions: 'Sometimes you have to break the rules to free your heart', he says to Marge. And that's the fairy-tale in a nutshell: to be true to yourself, to release desire, you have to transgress the laws of the academy, bourgeois society or the institution of art. But let's not be too glib: breaking the rules is often desirable and just as often produces great art, and yet, 'breaking the rules' has become a new law, and Wall detects a new institution in this popular and academic version of the avant-garde. Pictorial art, he reasoned, was 'inexhaustible' and could maintain the 'critical outlook' that he feels defines high art, while also offering an equally experimental alternative to the institutionalised avant-garde.

Yet Wall had been interested in 'New Left' politics for years, and many of his mid-1980s photographs begin by looking at the economic dialogues and conflicts of the era. Since he preferred to focus on, paraphrasing Sartre, the 'least-favoured members of society', his photographs presented snippets of an unfolding social crisis, dirty-realist narratives about people cast aside or damaged by the property relations dictated by capitalism. As spectators, we seem to come across these narratives *in media res*. Moreover,

AN EVICTION 1988/2004 [16]
Transparency in lightbox
229 x 414 (90 1/8 x 163)
Edition of 2

Stuart Franklin
NORTHERN IRELAND. BELFAST. RIOTS. 1985 [17]
Stuart Franklin/Magnum Photos

MILK 1984 [18]
Transparency in lightbox
187 x 229 (73 5/8 x 90)
FRAC Champagne-Ardenne, Reims

photographs such as *Bad Goods* 1984, *Diatribe* 1984, *The Thinker* 1985 and *Outburst* 1986 remain among Wall's most rhetorical pictures, and would seem to invite political readings more readily than any of his subsequent work. But looking at these photographs only as a kind of political commentary would diminish their complexity. Twenty years later, Wall downplays the political element in his 1980s work:

Every subject is a reason to make a picture. I don't like the idea of having extra-aesthetic interest in my subjects, as if I'm interested in them socially. When I began I was under the illusion that I did have those interests. I grew up in the 60s and 70s, amid the counter-culture and New Left, and I still believe in a lot of those things, but they don't really apply to my work. I once thought they applied to my work, but learned that they don't.

So although Wall wanted to capture the 'dirt and ugliness of the way we have to live', he wasn't interested in a didactic or overtly political art. It was essential that his pictures were complex and beautiful enough to provide more than a moral; he wanted to make a good picture, not tell a story or perform a good deed.

To do so, Wall started to think of the prose poem as a model for the creation and reception of his pictures. So we meet Baudelaire again. The nineteenth-century writer not only coined the term 'the painter of modern life' but he also perfected, in his book *Paris Spleen* 1860, the prose poem form. Furthermore, in his writings about art, he distinguished between poetic and didactic art, making it evident which he believed was the superior mode. 'The more art strives to be philosophically clear', he wrote, referring to so-called didactic art, 'the more it will degrade itself and revert towards the primitive hieroglyph'. Wall, naturally, wished to create a poem

rather than a primitive hieroglyph, but what did he mean by calling his pictures 'prose poems'? To answer this question it is useful to compare *Milk* 1984 (fig.18), one of Wall's strongest photographs from this period, to Stuart Franklin's *Northern Ireland. Belfast. Riots. 1985* (fig.17).

In *Milk*, our attention is initially drawn to the protagonist. He is clearly troubled: he is filthy, his shoes lack laces and his feet socks, and his jaw and fist, clenched tight, collude in an act of minor violence – the explosion of a carton of milk. The tempestuous shape of the burst of milk contrasts sharply with the grid-like order of the brick background, and its creamy purity also contrasts with the greasy, worn-out desperation of the man. The spectator is confronted by a mysterious, unpredictable component to the image that may suggest something hidden, and thus the milk evokes entropy, abstract art and purity, among many other things.

Franklin's *Northern Ireland. Belfast. Riots.,* with a male figure posed tensely against the imprisoning grid of a brick wall, reflects the structure of *Milk*, but this picture presents us with very different pleasures and problems. Franklin, a photojournalist, took the photograph to document an event. The central figure, though masked and anonymous, must be understood historically, against the backdrop of the troubles in Ireland. Wall's figure, on the other hand, is an actor and a protagonist in a fiction; he has no specific identity. We don't know *why* he crushes the carton to create this ejaculation of milk. Conversely, the frustration of the masked man, concentrated in the bright red stopper of cloth that tops his Molotov cocktail, has a specific context; the violence he is about to inflict is real and Franklin's photograph captures a tiny episode of a long historical conflict. In *Milk* the motivation for the act of violence is imagined

DOORPUSHER 1984 [19]
Transparency in lightbox
249 x 122 (98 x 48)
Goetz Collection, Munich

and therefore open to a variety of different readings, and this is partly what makes it a prose poem. Franklin's photograph is didactic insofar as it aims to teach us something about a specific time and place. We do not experience Franklin's picture as a prose poem but as straightforward, journalistic prose, and it succeeds because it illustrates an event with its own drama, elegance and purpose. *Milk*, on the other hand, succeeds because a plausible depiction of an everyday street scene is enhanced by the unexpected poetry of spurting milk. The white shape of the milk is the spatter of ambiguity that makes the picture work – it creates beauty because its flowing, natural form sets off a dialogue with the hardness and artificiality of the architectural backdrop. And without the burst of the milk, the poetry of the picture would be strikingly reduced. Wall makes the distinction this way:

You could have seen this – you might not understand it, but you could see it. Because it's not accompanied by any narrative, it's not journalism, meaning there's no accompanying story that proves to you that this is that and is caused by this – it can never be known. A journalist puts forward a truth claim in his account, and it's a very familiar one. I am also putting forward a claim, but mine is suspended; it's not proven or dismissed, but suspended, and in that suspension is pleasure. The claim is put forward not to be proved but to be experienced. I think that's key to the art of photography. If you put forward a claim in the form of a poem, then the claim is a poem, and the claim is the experience of the poem.

Despite the gritty social issues and political content in Wall's photographs such as *Milk*, *An Eviction* 1988/2004, *Trân Dúc Ván* 1988/2003, *Doorpusher* 1984, *Outburst* 1989 and *Bad Goods* 1984, he likes to call them 'the poems I was writing at the time'. In *Bad Goods* (fig.15), a native British

THE GOAT 1989 [20]
Transparency in lightbox
229 x 308 (90 x 121 1/4)
Art Gallery of Ontario, Toronto

Columbian, standing amid the dirt and ugliness of a worn-out urban landscape, glares at a pile of discarded lettuce (grown in California, thousands of kilometres south). In the background, 'For Sale' signs hint at the rapid buying and selling of land, wires and posts besmirch the sky and the immense grain silos remind us that most of our food, in a post-industrial age, is prepared like any mass commodity. The women in *Diatribe* (fig.22) look poor, on the outskirts of suburbia and the economy. *Doorpusher* (fig.19) features a slightly downtrodden figure reminiscent of the man in *Milk*. He may be poor, he may be a criminal, or he might be someone trying to perform a legitimate task. However, the blackened walls, charred door and freshly boarded window suggest that the building has recently survived a fire. This is a site of dereliction and violence. In *Trân Dúc Ván* (fig.21), a young Vietnamese man, filthy and forlorn yet also serene and beautiful, stands under a tree as if experiencing a flash of madness or enlightenment. All of these photographs might bring to mind photojournalism or an 'essay' on social and economic conditions. But, like *Milk* and unlike Stuart Franklin's *Northern Ireland. Belfast. Riots.*, we are faced with a situation severed from any obvious narrative or history, and so we have to look at the pictures in broad, metaphoric terms rather than as stories that illustrate an actual event. Soon after making *Milk*, *Mimic* and *Doorpusher,* Wall described the protagonists in these pictures as 'men who retained certain capacities, skill or strengths, but who could develop no creative use for them … these men have been thrown on the garbage pile, along with their natural abilities and possibilities.'

Wall's interest in characters 'on the garbage pile' emerged, no doubt, from the vivid cultural politics of the mid-80s, but René Girard – the writer whose idea

TRÂN DÚC VÁN 1988/2003 [21]
Transparency in lightbox
290 x 229 (114 ⅛ x 90)
Carnegie Museum of Art, Pittsburgh

DIATRIBE 1985 [22]
Transparency in lightbox
203 x 229 (79 7/8 x 90)
Ydessa Hendeles Art Foundation,
Toronto

of 'mimetic desire' was introduced in the discussion of *Mimic* – may also help to explain their presence. If *Mimic* could be looked at as an example of 'mimetic desire', Girard's idea of the 'scapegoat mechanism' helps to consider pictures such as *The Goat* 1989, *An Eviction, Trân Dúc Ván, Outburst* and *The Thinker*. A scapegoat, of course, takes the blame for a problem that is either imagined or caused by something else, and for Girard the omnipresence of scapegoats in myths – and everyday life – hints at a fundamental impulse in human culture. 'Mimetic desire' creates rivalries and erases differences, and this inevitably leads to irresolvable tension. Difference must be identified within a group. The tension can be relieved only by the elimination of a rival, or, according to Girard, by projecting tensions and aggressions on a surrogate victim. This process re-establishes the unity of a community, and thus myths and institutions are built upon scapegoats. For Wall, Girard's ideas could help analyse the tumult of the mid-80s, and his pictures are full of surrogate victims, or scapegoats.

In *The Goat* (fig.20) a group of young boys is poised at the brink of violence. All are dressed in approximately the same way – in a nice touch, most are wearing the 'converse' brand, though their 'conversation' is laced with tension and rivalry. These boys are like the boy in *Backpack*: their identities are wrapped up in the commercial culture of their era, and this produces a frenzy of mimetic desire because they all want the same thing. The tension can only be released by identifying a scapegoat to blame for the disintegration within their community. In ancient cultures, of course, the scapegoat was killed ritualistically, a process that re-harmonised the group. We don't expect the boy in the blue T-shirt to get his throat cut, but he might receive a hearty whack from a stick. Mimetic desire starts a cycle of deadly serious

play and ends with punishment.

Similarly, *An Eviction* (fig.16) depicts a community at a point of disintegration. The eviction may reflect the frequent repossession of homes that occurred toward the late 1980s, but the picture is remarkable in the way its formal properties reflect its theme. Everyone is brought together by this act of violence; the picture is fused by it, and in the aftermath, the community will be harmonised by discussion of the event. In *Outburst* (fig.14) the boss explodes in indignation at one of his workers, and the group is brought together, if negatively, by the act of violence. Wall portrays these tensions as formal properties of both pictures and human relations. Tension will always find its scapegoat, and pictures need formal tension to succeed. But the thematic content is inert if the poetry of the picture fails.

Of all the works from this period, the one that hits hardest with a strange, poetic logic is *The Thinker* (fig.23). 'An aged man is but a paltry thing, a tattered coat upon a stick', wrote Yeats, a description that perfectly evokes Wall's depiction of a man, no longer able to work and therefore cast aside by capitalism, who has become a scapegoat and a surreal element in an urban landscape. Perhaps, as the stump of wood suggests, he was a lumberjack, and his hands are no longer strong enough to fulfil his metier. Yet lightness of touch and humour also contribute to the picture's poetic qualities: Vancouver's city centre gleams Oz-like in the background, and the streetlamp droops as if it seeks a word with our pensive worker. His attitude reflects, of course, Rodin's *The Thinker* 1880, but in fact Wall based his thinker on Albrecht Durer's *Peasants' Column* 1525 (fig.24), a proposal for a monument that was never built. Wall describes the peasant who sits atop the column, the sword in his back a symbol of betrayal and defeat, as 'mourning for

Albrecht Dürer
PEASANTS' COLUMN [24]
book 3, plate 16 in 'Underweysung
der messung', Nürnberg 1525
The British Museum, London

THE THINKER 1986 [23]
Transparency in lightbox
216 x 239 (85 x 94 ⅛)
Private Collection, Munich

the fate of his and his class's hopes for emancipation'.

Revolution was at the heart of the avant-garde project, and many of Wall's pictures from this period evince nostalgia for that impulse. But revolutions found their new institutions on the corpses of scapegoats, so Wall sought, instead, a form of dialogue. Even a landscape from the period, *The Holocaust Memorial in the Jewish Cemetery* 1987 (fig.25) is structured as a conflicted dialogue. The soft greens and blue hills set against architectural forms bring to mind the pastoral landscapes of Claude or Poussin, and the tombstones look curiously like a Carl Andre or Donald Judd installation. Again, the pastoral ideal collides with modernity. The pictorial dialogue between the Memorial and the bridge in the background holds the composition together. Like the figures in *Outburst* or *The Goat*, these structures establish a formal tension; they push and pull each other across the picture plane. The structure may even propose a dialogue between utilitarian progress (the bridge) and the events of the Holocaust, the greatest humanitarian catastrophe – and the most extreme form of the scapegoat mechanism – of the twentieth-century, whose very existence, according to Theodor Adorno, makes post-Holocaust poetry impossible. This landscape acknowledges the limits of both ethical and artistic perfectibility and progress, a nineteenth-century myth essential to the avant-garde and the New Left of the 1960s and 1970s. But Wall is not giving up or proposing a return to some forgotten tradition. *The Holocaust Memorial in the Jewish Cemetery* is a mournful prose poem, a patch of hesitant beauty wrought from the ineluctable conflict and dialogue inherent both in human relations and in good pictures.

THE HOLOCAUST MEMORIAL IN THE
JEWISH CEMETERY 1987 [25]
Transparency in lightbox
119.4 x 216 (47 x 85)
Edition of 3

In 1986, Wall wrote a short text to accompany his photograph *The Storyteller*. It is reprinted here, along with an interview in which he discusses how his understanding of the picture has changed since he made it.

The Storyteller

The 'figura' of the storyteller is an archaism, a social type which has lost its function as a result of the technological transformations of literacy. It has been relegated to the margins of modernity, and survives there as a relic of the imagination, a nostalgic archetype, an anthropological specimen, apparently dead. However, as Walter Benjamin has shown, such ruined figures embody essential elements of historical memory, the memory of values excluded by capitalist progress and seemingly forgotten by everyone. This memory recovers its potential in moments of crisis. The crisis is the present. This recovery parallels the process in which marginalized and oppressed groups reappropriate and re-learn their own history. This process is in full swing and its impact is transforming standard criteria of literacy, creating openings for a newer concept of modernist culture, one not so unilaterally futuristic as the one still reigning in Europe and North America.

The Native peoples of Canada are a typical case of the dispossession. The traditions of oral history and mutual aid survive with them, although in weakened forms. So the image of the storyteller can express their historical crisis. The focus of Native education is on the rediscovery of cultural identity, which implies a reconstruction of history, and so possibly a reinvention of archaic figures like the storyteller. That could maybe provide a new 'figura' within modernism, one among many, I hope, which would emblematize peace, knowledge, frankness, sympathy, high spirits, fearlessness, acumen, dialogue, cunning, economy, passion.

CRAIG BURNETT: How did you find the location for *The Storyteller*?
JEFF WALL: *I've known the location forever. One day I saw almost exactly that scene, just around the corner from where I made the picture: some people sitting around a fire in the morning.*
CB: What did that trigger in you?
JW: *It just triggered a picture. Every subject is a reason to make a picture. The* Storyteller *could have been made at that place with another subject and it might've been good. So there was no particular reason to make the picture, even though I*

thought there was at the time. At the time, I thought the act of holding a discussion in the midst of trouble and deprivation was an image of the way to create some sort of alternative space. But if you look at the picture there's no sense of it being an alternative to anything; it's just what happens in a situation like that. I interpreted it as an image of an alternative when I made the picture, but now I think I was wrong; that meaning isn't necessarily in the picture. Nor is there any sense that the woman is conveying anything of any importance, anything more important than something that matters just to her. It's ambiguous and I like that. When I realised this a few years after finishing the picture, it was bit of a shock to learn that my own interpretation of my picture was incorrect. That was refreshing because it made me feel I was seeing it again, like a new picture.

CB: You almost get the feeling that the group has been there for thousands of years, that everything just moved in around them.

JW: *That's an interesting way of looking at it. What's going on could have been going on before the bridge was there. If it evokes that, that's good. So then it's an anachronism, and then suddenly it's real and imaginary at the same time, as well as allegorical.*

CB: What about the collision of human forms and natural forms?

JW: *I don't see a collision, but a gathering of attractive forms – the figures, the planting, and the beautiful, hull-like underside of the overpass. I like the fact that when you really look at the world, conceptual oppositions collapse, or become much more complex. You realise that the concrete overpasses are neither majestic sculptures nor hideous, oppressive monoliths. They're just experiential spaces that we see in different ways. That's what's so beautiful about photography.*

CB: You must have been aware of the allusions to Manet.

JW: *The allusion to Manet was a semi-accident. When the performers gathered around the fire they had to find a way to sit comfortably. I said, 'You sit here, you sit there, etc'. The man who was listening was on a certain part of the slope and he put his hand up to his chin like that. I didn't ask him to do it that way – he just did it because it was a way for him to sit. It happened to resemble the gesture made by the nude woman in Manet's* Déjeuner sur l'herbe *and everyone picked up on that, but it wasn't planned. It could've been. It happened, and therefore the resemblance is there, and because of the subject matter the resemblance means something. Even though I didn't plan it I set in motion some sort of energy that led to that and even if it's partly*

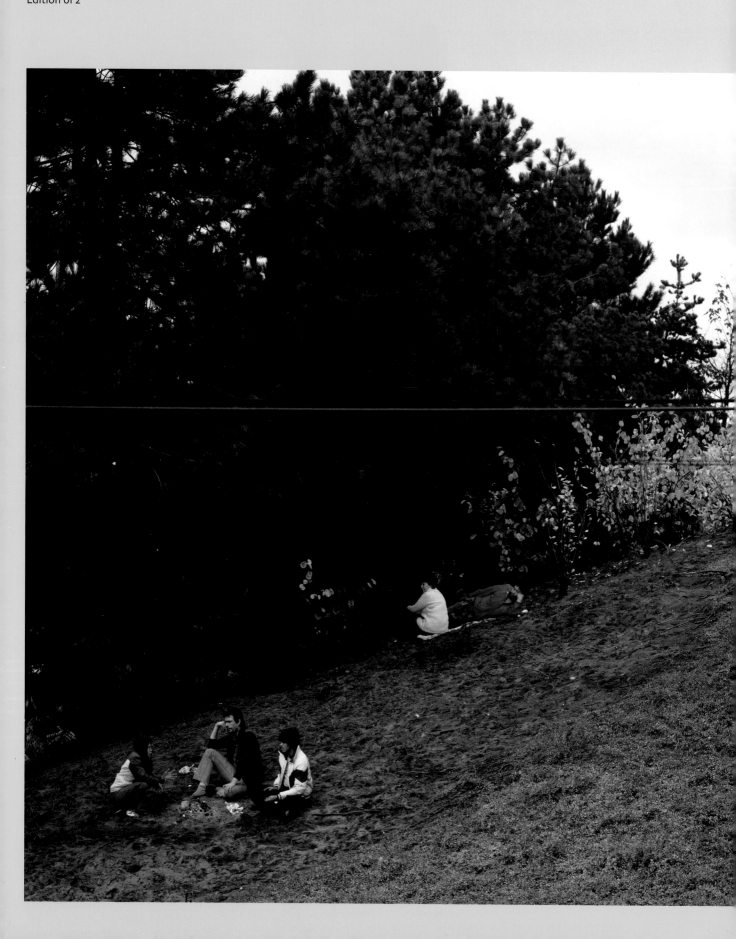

THE STORYTELLER 1986 [26]
Transparency in lightbox

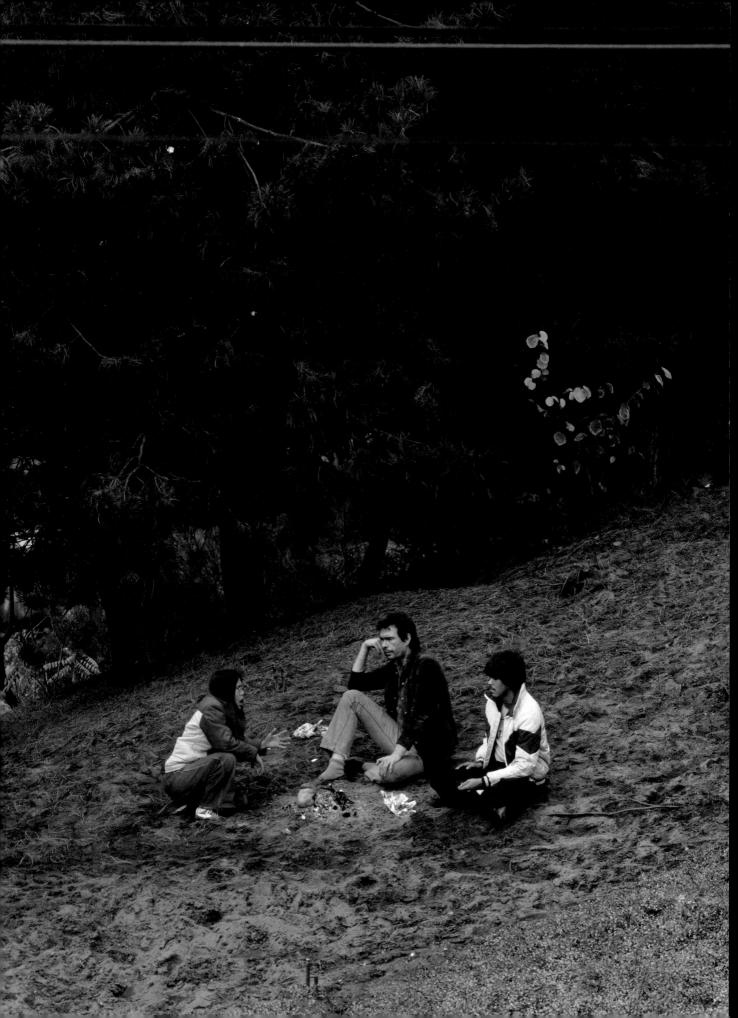

by accident, I'm responsible for it and I'm happy that it's there. But on the other hand, even though I didn't plan that gesture, I knew that I was doing a picture that had to relate somehow to Déjeuner sur l'herbe.

CB: So it seems that part of your pleasure as an artist is that you find these things by accident during the process of making a photograph.

JW: *Partly by accident and partly by trying; I never know which is which. It's a great pleasure: it's like painting and having a drip fall and changing that shape into another shape. I think of it as akin to the way de Kooning would draw. He might start with an ellipse and then the brush would accidentally do something and make a new shape and he'd respond to that, and so on.*

COASTAL MOTIFS 1989 [27]
Transparency in lightbox
119 x 147 (46 7/8 x 57 7/8)
Edition of 3

THE DRAIN 1989 [28]
Transparency in lightbox
229 x 290 (90 x 114 ⅛)
Kunstsammlung Nordrhein-
Westfalen, Dusseldorf

EVERYDAY FANTASIES AND IMPOSSIBLE REALITIES (1989–93)

3

In 1988–9, Wall felt he had painted himself into a corner, but emerged from this minor crisis a more complete artist. Looking at a few pictures from the late 1980s, including *The Goat, Outburst* and *The Drain* 1989, he thought his work had become too wrapped up in capturing the unfolding of an event and the resulting emphasis on arrested motion. He realised that he was having a battle with photography, and photography was winning. 'I tried something,' recounts Wall, 'failed, and that failure opened up something much more interesting, which was to accept photography in a way that I hadn't been prepared to until then'. The consequence of this realisation was a broader vision of photography, one that embraced modest still lifes such as *Some Beans* 1990 and *An Octopus* 1990 but also an elaborate, action-filled tableau like *A Sudden Gust of Wind (after Hokusai)* 1993, based on a nineteenth-century woodblock print and created with the help of computer montage.

In *The Drain* (fig.28), two young girls play in a stream at the gaping mouth of a drainpipe. Although the scene might suggest a couple of schoolgirls on an everyday visit to a local park before they go home for lunch, it also evokes an atmosphere of fantasy and the surreal, and seems to have some Freudian nightmare as its thematic bedrock. The menacing black hole may threaten to swallow the girls, or their innocence, and the picture is loaded with narrative portent. Perhaps these girls should be somewhere a little dryer and safer, or we could even imagine that the one on the right, standing aggressively on the rock, bullies the other, who seems just as terrified by her companion as she is by the eerie emptiness at the heart of the picture. The action in *Outburst* and *The Goat* seems to stop just before an inevitable eruption of violence. *The Drain* is more ambiguous, yet there is also a feeling

that, after the frozen moment depicted by the picture, something unpleasant might happen.

Coastal Motifs 1989 (fig.27), by contrast, betrays little suggestion of a specific event, and the picture harkens back to earlier landscapes such as *The Bridge*. The city of Vancouver hangs off these coastal mountains, a near-wilderness across the Burrard Inlet (visible in the middle of the picture) to the north of the city, where suburbs creep into the cool rainforest. The presence of an industrial site might suggest that the menace of environmental degradation is the violence or theme depicted here, but Wall sees it differently: 'I was impressed with the way we'd come to terms with the coastline, using it but not obliterating it. I thought the area was very gentle, really.' Instead of an emphasis on 'cinematographic' frozen motion, we have an expansive landscape, in which the romanticism of untainted wilderness balances an industrial, utilitarian coastline. In fact, the view in this photograph, taken from a spot between his studio and Simon Fraser University, where he had worked until 1987, would have been very familiar to Wall, a quotidian vista immediately to the north of where he still spends most of his working life (The site of *Coastal Motifs* is just a couple of hundred metres away from the site of *The Thinker*). But perhaps he felt unready to take this photograph at this time; perhaps he didn't see it during his years at SFU because it was too familiar or perhaps he ignored the landscape simply because he was interested in making different kinds of pictures. He revisits this view, which is only a couple of kilometres from the studio he acquired in 1987 and still uses today, as if recapturing a simple beauty – and an uncomplicated feeling about the nature of photography – that had been unavailable to him before.

Some Beans and *An Octopus* (figs.29, 30) – two

THE STUMBLING BLOCK 1991 [31]
Transparency in lightbox
229 x 337.5 (90 x 132 7/8)
Ydessa Hendeles Art Foundation,
Toronto

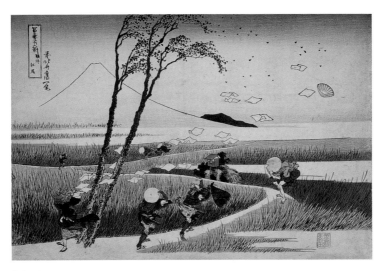

Hokusai
A HIGH WIND IN YEIJIRI c.1831–3 [32]
Colour print
26 x 37 (10 1/4 x 14 5/8)
The British Museum, London

pictures of food laid out on the same, bare table – have a gentle, earthy quality, and provide an essential register for the change in Wall's work during the early 1990s. The subjects are allowed to inhabit a rustic interior uncluttered by any hint of narrative, and the mood is tranquil. These two pictures evoke, of course, the still life tradition, but the photographs probably reveal a stronger affinity with bodegones paintings (from bodegon, a humble inn or pub), the Spanish genre pictures of food and interiors painted by Velázquez, among others. Seventeenth-century Dutch still lifes, those lurid *momento mori*, depict ostentatious piles of exotic food and worldly goods that are meant to remind us that, one day, we will all decay like a glistening slab of fish or a piece of peeled fruit. *Some Beans* and *An Octopus*, are warmer, less didactic. If still lifes deliver cold lessons about the vanity of human existence, these works come across as gifts, helping Wall to realise that 'cinematographic' photography need not depict an arrested moment to be powerful.

Yet Wall's realisation did not eliminate his penchant for drama: after a few pictures that seemed to offer fables about simplicity and gentleness, Wall embarked on an ambitious series of elaborate, multi-character tableaux brimming with black humour: *The Stumbling Block* 1991, *Vampires' Picnic* 1991, *A Sudden Gust of Wind (after Hokusai)* and *Dead Troops Talk* 1992. In *The Stumbling Block* (fig.31) Wall used digital technology for the first time, photographing individual elements on the street and studio before working with a computer to create a seamless montage. He had encountered digital technology in the early 1980s, and the possibilities it presented immediately appealed to him. Initially, however, the resolution was too low and the computers were achingly slow, so he let the technology catch up for about eight years. Once sufficiently quick, Photoshop offered a powerful method of cropping and composing a picture, in the same way that a painter might plan, sketch, scrape and repaint a picture. The introduction of computers also meant that Wall did not have to rely on the contingencies presented by the split-second click of the shutter (though he did not give up 'documentary' photography). Digital technology offered, it seemed, a new kind of control, and could have broadened the possibilities of what it means to take 'cinematographic' pictures to the point of vertigo. After all, computers allow artists to depict a world in which gravity and other inconveniences of existence are immaterial, and as Hollywood had shown, filmmakers could make any fantasy appear on screen. Why not make photographs of fluttering putti or knights smiting ferocious dragons?

This question can perhaps be answered by *The Stumbling Block* – a comedy about the vertiginous freedom offered by computers. It suggests that the material world, whatever our Hollywood dreams, is not infinitely plastic. The photograph is a surreal slapstick that flirts with pictorial anarchy, though it maintains the unity of action essential to Wall's vision. The setting – downtown Vancouver – and characters – a bunch of people going about their business – could scarcely be more mundane. In the foreground, the Stumbling Block, a middle-aged man in what looks like bomb-defusing gear, appears relaxed as a woman topples over him. Many of the pedestrians fix their stares on him, as if they want to trip over him, too. Some sort of government employee from the 'Ministry of the Stumbling Block', the man in elaborate padding provides a curious public service, laying himself across the pavement like the stone that Samuel Johnson kicked in order to refute George Berkeley's claim that reality is just an

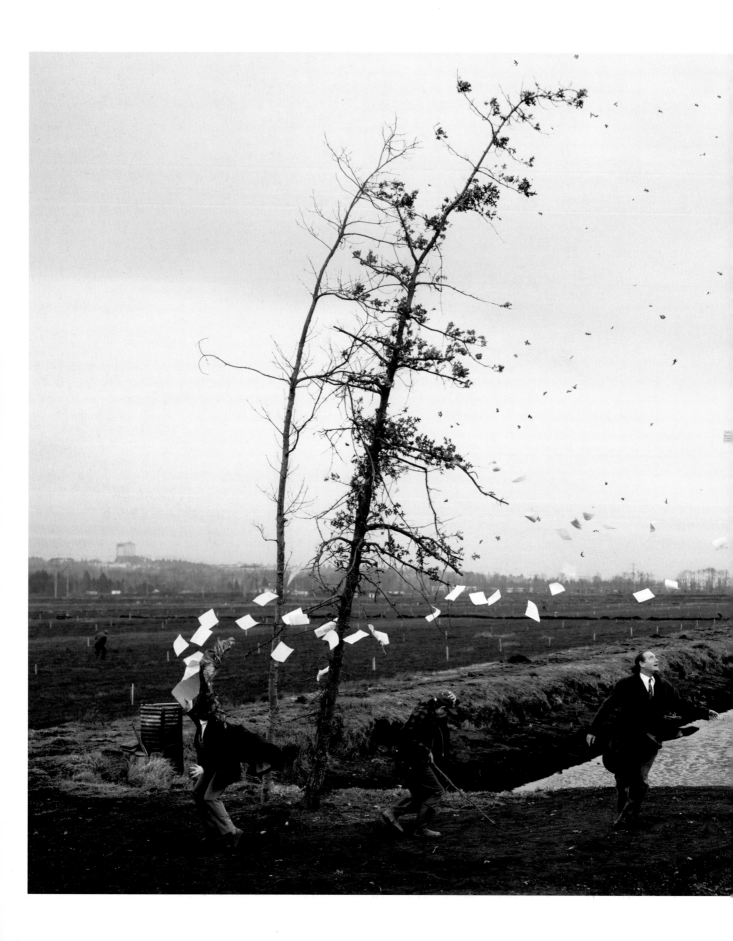

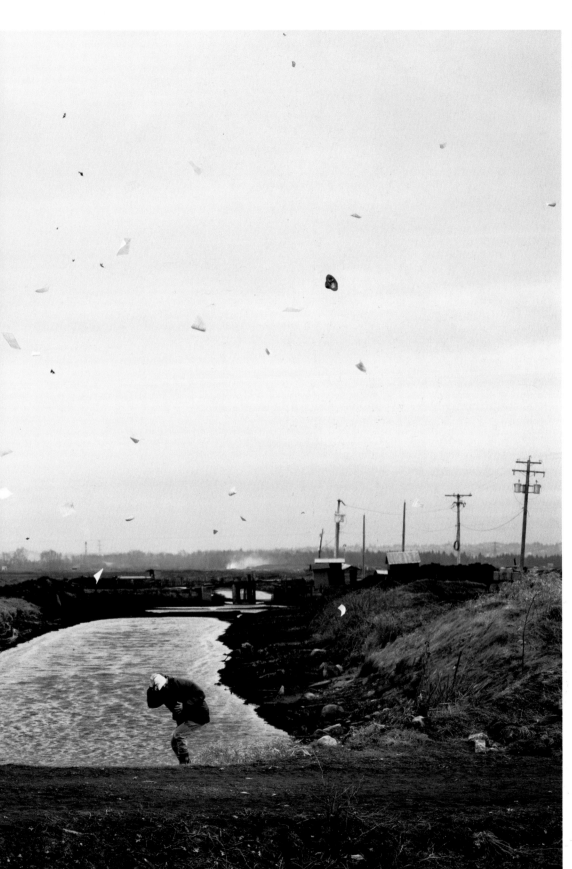

A SUDDEN GUST OF WIND
(AFTER HOKUSAI) 1993 [33]
Transparency in lightbox
229 x 377 (90 x 148 3/8)
Tate

ADRIAN WALKER, ARTIST, DRAWING
FROM A SPECIMEN IN A LABORATORY
IN THE DEPT. OF ANATOMY AT THE
UNIVERSITY OF BRITISH COLUMBIA,
VANCOUVER 1992 [34]
Transparency in lightbox
119 x 164.3 (46 7/8 x 64 5/8)
Edition of 3

idea, that things exist only in the perceiving mind. The Stumbling Block, prone and grinning, is a friendly government reminder of the inconceivable richness of everyday, material reality. He prompts Wall to remember that, despite his newfound omnipotence, computers do not unlock a unique way to imagine the world.

Wall has spoken about *The Stumbling Block* as a form of therapy 'available for anyone who somehow feels the need to demonstrate – either to themselves or to the public at large – the fact that they are not sure they want to go where they seem to be headed.' It is a public service that allows people to hesitate, to drop out of the rat race and reconsider their desires and ambitions. For a clue to the title, we should look again to René Girard. Mimetic desire, we remember, is desire based on a model: we long for what another longs for. That model, in Girard's writing, is called a 'stumbling block' (translated from the Biblical Greek, skandalon), because it is also an obstacle, and 'so becomes an inexhaustible source of morbid fascination'. With a computer, there is, presumably, nothing to block the fulfilment of all desire. But whose desire? Although *The Stumbling Block* may represent a kind of government-sponsored therapy, it is also the object upon which we fixate in the absence of our own desire. *The Stumbling Block* leaves us on the hard ground, recovering from a tumble, confused and saturnine.

A Sudden Gust of Wind (after Hokusai) (fig.33) is rather more light-hearted in its lesson about the inescapability of the material world. Based explicitly on Hokusai's *A High Wind in Yeijiri* (1831–3, fig.32), *A Sudden Gust of Wind* is a remake of another picture in the manner of *Picture for Women*. The setting for this comedy of gravity, weather and contingency is a cranberry farm outside Vancouver, and the cast of

characters includes farmers and white-collar workers. Perhaps the well-dressed man and woman are bureaucrats or bean counters, away from the office to inspect the farmers' books. But when a gust of wind blows their efforts to impose order and organisation skyward they are suddenly, like the farmers, subjected to the capricious forces of the weather. Ideas – in the form of papers – take flight in an unexpected gust, equalising the group under nature. Constructing his pictures digitally from individually photographed elements, Wall likes to remind himself that the intoxicating freedom of computers is an illusion. We are not divine but error-prone and mortal, as these comedies remind us, and *A Sudden Gust of Wind* is a marvellous evocation of the contingencies of everyday life.

In *The Vampires' Picnic* (fig.35), the macabre, supernatural atmosphere was achieved without the aid of computer montage. *Vampires* seemed to be on everyone's minds in the early 1990s, perhaps because AIDS had given blood and bodily fluids such a sinister tang. Francis Ford Coppola made *Dracula* 1992, Anne Rice's campy 'Vampire Chronicles' were runaway bestsellers and, in the art world, Marc Quinn created *Self* 1991, a self-portrait made from his frozen blood. Wall has commented that *The Vampires' Picnic* is partly a parody of garish group portraits of avaricious – i.e. blood-sucking – families in hit soap operas such as 'Dallas' and 'Dynasty'. Thus it depicts the aftermath of the kitschy, rapacious 1980s, a kind of cultural hangover during which the economy laboured under recession. This juxtaposition of the spectral (vampires) with the banal (a family portrait, a picnic) is typical of Wall's approach. 'I can't draw a sharp distinction between the prosaic and the spectral,' he comments, 'between the factual and the fantastic, and by extension between the documentary

THE VAMPIRES' PICNIC 1991 [35]
Transparency in lightbox
229 x 335 (90 x 131 7/8)
National Gallery of Canada, Ottowa

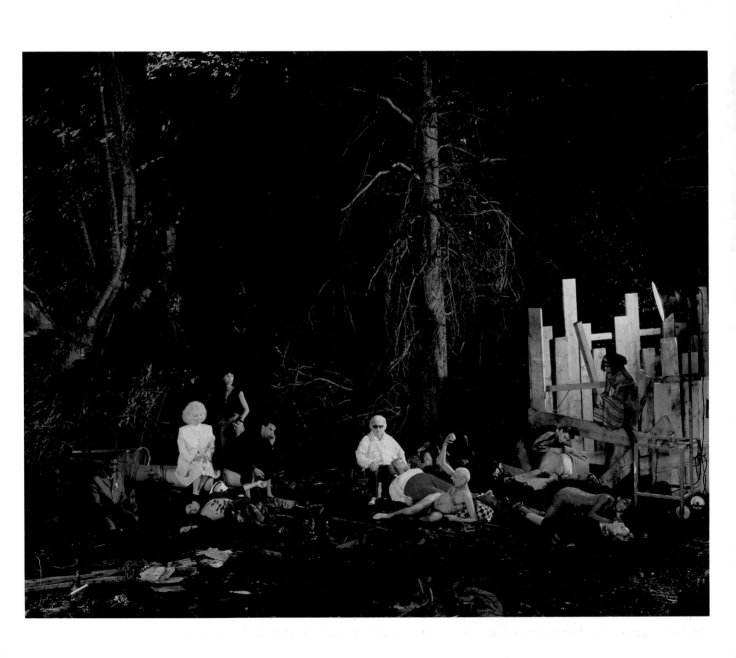

and the imaginary. "Cinematography" is my way of working on this.' *The Vampires' Picnic* uses vampirism as an elaborate metaphor for the kitschy, blood-soaked culture of the time, but it is also a complex picture that questions the division between the spectral and the everyday, and the link between transgression and cultural progress.

In the light of Wall's comments about the factual and the fantastic *Adrian Walker, Artist* 1992 (fig.34), is a gentler take on the macabre, and offers a helpful counterpoint to *The Vampires' Picnic.* The preserved arm that the artist sketches would not look out of place among the limbs of *The Vampires' Picnic,* but the rest of the setting is bright and sanitised. The relationship between the artist (who was one of Wall's students and occasional assistant) and his 'victim' is a stark contrast to the vampires; the artist creates something true and beautiful from this fragment of death, whereas a vampire kills to feed his own blood lust (creating a new vampire, of course, and thus adding to an endless chain of death). This picture conveys a humility and high seriousness in the face of material existence, whereas the vampires flaunt lust, anxiety and creepy indifference in equal measure. In *Adrian Walker, Artist,* death haunts the everyday as the artist seeks to comprehend it by studying its every detail; in *The Vampires' Picnic,* fear of death provokes fantasy and debauchery.

Adrian Walker, Artist also looks at the nature of representation, inviting us to wonder whether Walker's sketch is an accurate depiction of the preserved arm or an expressionistic interpretation. The copy of *Don Quixote* on the shelf is enough to warn us about interpreting art in the romantic, literal-minded fashion of the Knight of the Sorrowful Face, but also that the earthiness of Sancho Panza is insufficient. Or perhaps it would be best to say that

both are equally valid and necessary. Indeed, the picture, coupled with *Vampires' Picnic,* collapses fantasies and everyday events into one, indivisibly complex version of the real. 'I've been very much affected by living within the two founding myths of photography,' says Wall, 'The first being that photography creates truth, the second that it doesn't. Like all antinomies, the two opposites are less distinct than they appear to be.' Hence we find the transcendent friendship between Sancho Panza and Don Quixote, the union of utility and aesthetics, so convincing and vivid.

Wall's impulses towards the spectral and the prosaic, fantasy and everyday, expression and truth, are partly resolved in *The Crooked Path* 1991 (fig.36). Unusually, he began with a title in mind and then set out, as he often does, in his car to look for a site that he could photograph. Eventually, he settled on this 'bandit path', as urban geographers call them, a little trail established not by official but by frequent, popular use. On one level, the picture is a mundane urban landscape, a cluster of valueless vegetation beside some industrial buildings. On another level it can be seen as the crooked path that Wall travels through photography, one that can swerve towards a documentary mode or follow a more cinematographic method haunted by fantasy, complexity and the history of painting. Wall revels in this indistinct and rambling route. The picture itself illustrates the point: it is both straight photography and an essay on aesthetics. The path is natural and homespun; no one laid it or put restrictions on its use. It is open and democratic, and beautiful because it was formed by the accretive decisions of countless walkers.

The Pine on the Corner 1990 and *The Giant* 1992 together provide a good illustration of how Wall resolves this seemingly contradictory interest in the

THE CROOKED PATH 1991 [36]
Transparency in lightbox
119 x 149.2 (46 7/8 x 58 3/4)
Edition of 3

factual and the fantastic. *The Pine on the Corner* (fig.38) is a straight, documentary photograph whereas *The Giant* (fig.37) is a digitally enabled fantasy, yet they are strikingly continuous in mood. A single, transfixing presence dominates each image: an enormous tree in the former and an enormous naked woman in the latter. Standing in a library, she comically refers to a scrap of paper, as if she were trying to find a particular book. Her fleshiness and age are essential to the picture: she's not nubile enough to be the dewy-eyed dream of some book-weary student's libido. Yet her breasts and skin, in contrast to the rigid, Escher-like levels of the library, are enormously tangible, and we may cringe at her nakedness even though her immensity makes what we see impossible. The enormous pine tree, despite growing on a dull street corner in east Vancouver, is equally a mixture of strangeness and beauty; this kind of pine tree does not grow naturally on the coast, and yet it has clearly been there longer than the houses and cars over which it towers. In each case, Wall finds tension in incongruity: one is a supposedly truthful picture while the other is a hilarious daydream. The pine tree would seem to reference Cézanne's extraordinary pine trees and, perhaps, his comment 'I will astonish Paris with an apple'. The tree, like Cézanne's apple, is a celebration of the fantastic in the everyday. 'When I first started working digitally', comments Wall, 'I was under the illusion that the computer was opening a world of imaginary spaces. But the everyday is a special effect. There's no special space that is imaginary.' *The Pine on the Corner* and *The Giant* lead us into the pleasantly irresolvable world of pictures, where some unadorned corner of the everyday suddenly springs to life as an inexplicable fantasy. Nearby, a naked giantess looms, simply on the lookout for something good to read.

THE GIANT 1992 [37]
Transparency in lightbox
39 x 48 (15 3/8 x 18 7/8)
Edition of 8

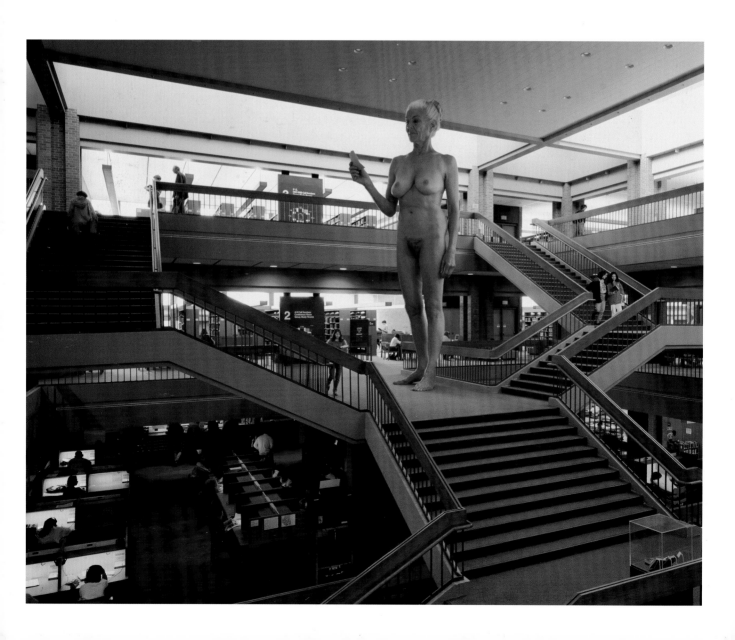

THE PINE ON THE CORNER 1990 [38]
Transparency in lightbox
119 x 149 (46 7/8 x 58 3/4)
Edition of 3

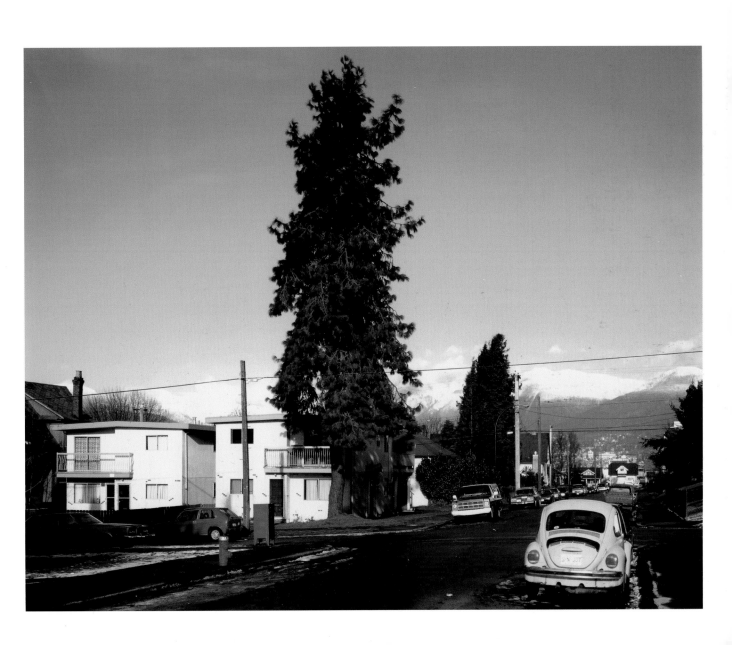

DEAD TROOPS TALK (A VISION AFTER AN AMBUSH OF A RED ARMY PATROL, NEAR MOQOR, AFGHANISTAN, WINTER 1986) 1992

The discrete elements of *Dead Troops Talk (a vision after an ambush of a Red Army Patrol near Moqor, Afghanistan, winter 1986)* were photographed in sections over a few months in Jeff Wall's studio and the final picture was pieced together using computer montage. He wanted to make a photograph of soldiers becoming aware of their death immediately after they had been killed. The Afghan War, active during the planning and making of the picture, provided the raw material. As he often does, Wall worked out the nature of the scenario by making drawings for the set and figures before beginning photography. During the course of his research, Wall came across a newspaper photo of Russian soldiers trading Kalashnikov clips for hash with the Mujaheddin, a serendipitous encounter that added another dimension to Wall's 'dialogue of the dead'. The photograph might depict a hash-induced hallucination – it could be that of a Russian or an Afghani soldier – that occurs in the lull immediately after the ambush, in which the soldiers awake from death, their bodies scarcely intact, to discuss their fate.

The structure and theme of *Dead Troops Talk* relate to French nineteenth-century Salon Machine paintings such as Antoine-Jean Gros's *Napoleon on the Battlefield at Eylau, February 9, 1807* 1808 (fig.39).

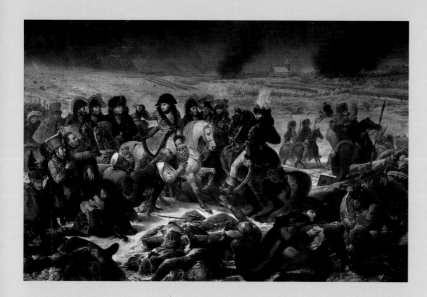

Antoine-Jean Gros
NAPOLEON ON THE BATTLEFIELD AT EYLAU,
FEBRUARY 9, 1807 1808 [39]
Oil on canvas
521 x 784 (205 x 308 5/8)
Musée National du Louvre, Paris

CRAIG BURNETT: *Dead Troops Talk* inverts what we usually expect from war photography. What prompted you to convert something that is unbearably real – violent death – into a fantasy?

JEFF WALL: *The subject occurred spontaneously. I had a sudden notion of a dialogue of the dead, coming from I don't know where. It had nothing to do with the Afghan war, but the subjects needed to be soldiers because it seemed important that they would have died in an official capacity, that would surely give them something to talk about. I must have worked on it for six or seven years, making sketches and thinking about how to do it, before I ever got around to making it. At the time I was thinking about it, the Afghan war was coming to an end. That was a coincidence. It always seemed to me that the work was going to have a relationship to war photography. I was going to advance a claim to authenticity that couldn't be satisfied, and in the suspension of that area – the fantasy – the hallucination could occur. I also thought that it could have a relationship to the Salon Machine paintings of the nineteenth century – but without Napoleon, without the hero. But the picture has nothing to do with pastiche – it's not meant to be amusing, but sombre and contemplative. It has some comic elements in it, but that's not the essential nature of the picture. It's not a comedy. I've made other comedies, but that's not one of them. I feel that the literary, thematic core of it is: what would we say if we could speak about our death having died for a cause that we might not understand or even agree with but which we would nevertheless accept as we accepted, acquiesced or submitted to being soldiers? The pictorial realisation of the theme had to be hallucinatory, but the hallucination needed a foundation of almost documentary accuracy. All the factual elements had to be as real as I could make them.*

CB: The setting, the uniforms and the nature of the wounds, for example?

JW: *Yes, that was all carefully researched so that it could be factually correct. It was important to have that level of plausibility, and it's more interesting aesthetically to do it that way. It has a relation to ways of seeing the truth, but it doesn't have a direct relation. That's why I called it a 'hallucination', a 'vision'.*

CB: Can you talk about the relationships between some of the soldiers?

JW: *Creating the relationships was like writing a scenario or a narrative poem. There are thirteen men, one patrol, all killed, but each reacting to that in his own way. It's not a synopsis of humanity; it's a fragment – just these thirteen men. The young boy whose head is blown open and has lost his hands is in a way the central figure, and*

DEAD TROOPS TALK (A VISION AFTER AN
AMBUSH OF A RED ARMY PATROL, NEAR MOQOR,
AFGHANISTAN, WINTER 1986 1992 [40]
Transparency in lightbox
229 x 417 (90 x 164 ⅛)
Edition of 2

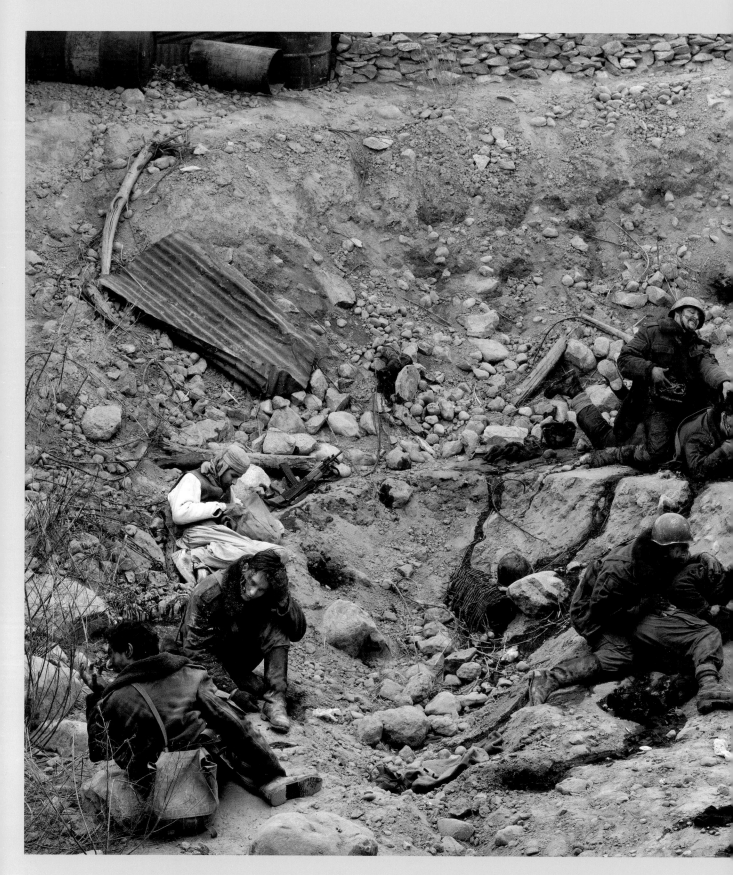

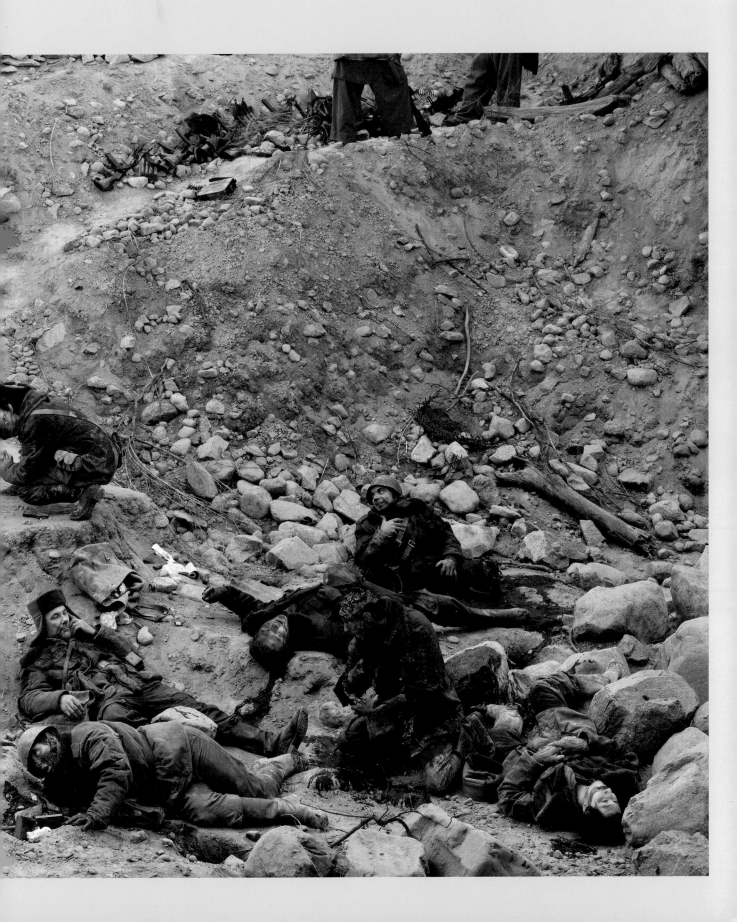

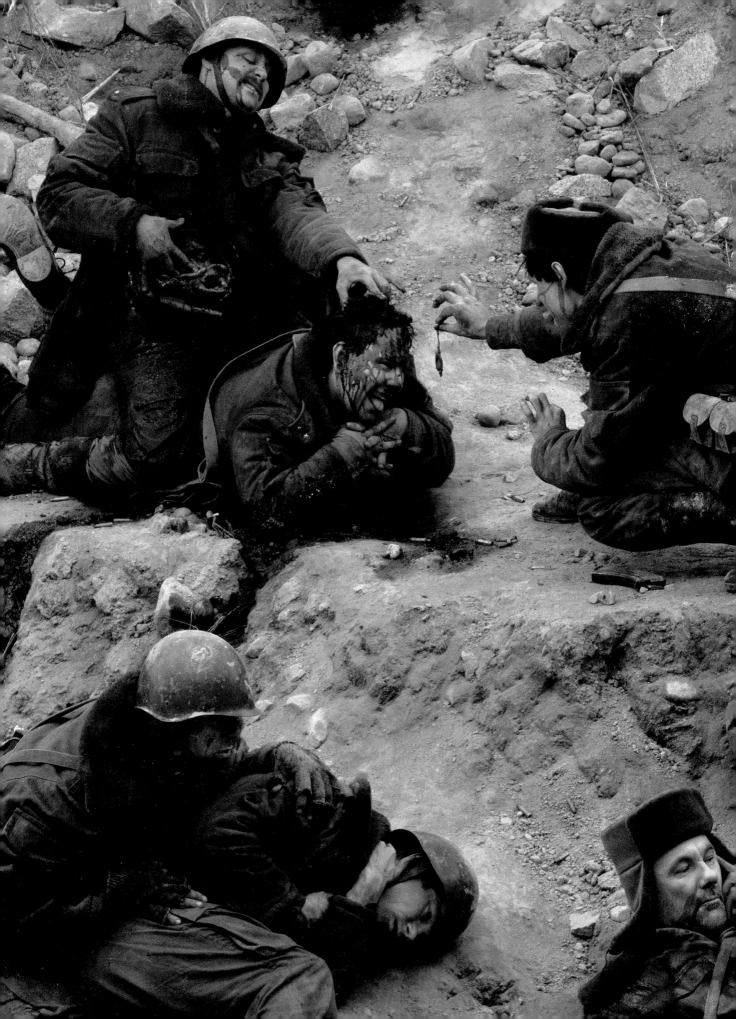

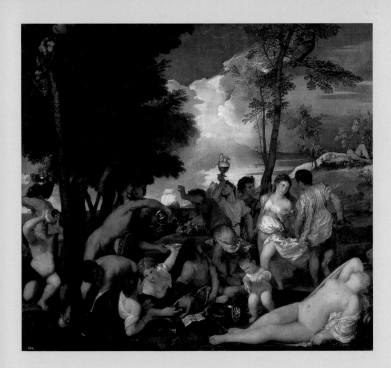

Titian
THE ANDRIANS 1523–5 [41]
Oil on canvas
175 × 193 (68 7/8 × 76)
Museo del Prado, Madrid

he's saying something that he feels is urgent to the older captain But because the captain's dead too, he's also moved into another dimension, one in which he doesn't have to answer. There's no urgency – he's contemplating this boy's questioning nature, or contemplating the urgency itself, who knows? I tried to find ways for each figure to go through this moment, as an individual, each one somehow different. With the group of three 'clowns' at the back, I wanted to involve an element of levity, but without comedy. I felt that would make the overall picture more serious. In any group of thirteen men, three at least are going to be complete fools. So it's likely they would remain fools even after death. On the other hand, maybe they weren't fools before, and only became so once they were killed.

CB: They seem to be saying, 'You're dead!' 'Yeah, well, you're dead, too.'

JW: *Exactly. 'I'm more dead than you! Look at the hole in my head!*

CB: It also struck me as a hellish version of Bacchanalian scenes such as Titian's *The Andrians* [1523–5, fig.41] or Poussin's *The Triumph of Pan* [1636].

JW: *The picture does relate to that tradition. You have to animate a group of figures by means of rhythm. The painters had to create a flow through the composition. I tried to do that with* Dead Troops, *too, but it has a broken rhythm, something like modern music. It has a grotesque aspect. The intervals and shapes are all about break-off and collapse, with sudden openings and gaps and then something again, something fractured.*

PARK DRIVE 1994 [42]
Transparency in lightbox
119 x 136 (46 7/8 x 53 1/2)
Edition of 3

SWEPT 1995 [43]
Transparency in lightbox
174 x 216 (68 1/2 x 85)
Edition of 2

THE STILL POINT OF A GOOD PICTURE (1993-6)

4

During the early 1990s, Wall considered making a photograph of restorers at work on a painting. He travelled to Munich to watch restorers going about their task at the Alte Pinakothek, but he left unsatisfied: a framed rectangle on a pictorial scale seemed insufficient subject matter for the picture he had in mind. Then, while Wall was in Lucerne, Switzerland to discuss a possible exhibition of his work at the Kunstmuseum, the curator Martin Schwander showed him the Bourbaki Panorama. He was immediately taken both by the beauty of the space and by the quality of the painting. Looking at this immense panorama, a spectacular *gesamtkunstwerk* that seemed to augur the mass-appeal of Pop art and the early days of modernism, he knew he had found his subject for *Restoration* 1993 (fig.44).

Painted in 1881 by Edouard Castres and a team of assistants, the Bourbaki Panorma is a depiction of about 87,000 French troops who were granted internment in Switzerland and given treatment by the Red Cross after a defeat during the Franco-Prussian War (1870–1). The 360-degree painting is enhanced by 'faux-terrain' – sculptural elements installed to create a naturalistic foreground in order to ease the viewer's vision into the painting's surface. Because it attempts to leave nothing unseen ('panorama' is from the Greek for 'see all'), excessive ambition haunts the work. Its vast, all-encompassing format introduces an inevitable whiff of bathos because its ambition extends beyond its means, and because part of our experience of the panorama will be a gnawing awareness of its heightened artificiality. The fin-de-siècle age in which it was painted was drunk on art; across much of Europe, 'art for art's sake' was the mantra, and thinkers as diverse as Matthew Arnold and Stéphane Mallarmé sought a new kind of spirituality or mysticism in art after religion became a

shattered currency in the nineteenth century. 'The fact that panoramas emerged so strikingly', comments Wall, 'and then died out so quickly, suggests that they were an experimental response to a deeply felt need, a need for a medium that could surround the spectators and plunge them into a spectacular illusion. The panorama turned out to be entirely inadequate to the challenge'.

But the Bourbaki Panorama was perfectly adequate for Wall's picture. He was attracted to it for a combination of reasons: the beauty and curvature of the space, the quality of the painting itself (most panoramas of the era, now destroyed, were more popular spectacles than high art) and its unusual theme: this is a war picture about altruism and healing rather than victory or the spectacle of battle. Wall asked a group of professional restorers to set up as if they were in the early stages of restoration, then took several hundred pictures with a panoramic camera before creating the final image with computer montage. Wall's picture helped stimulate debate about the actual restoration of the panorama, which began within a few years of the photograph, and was finished in 2000.

In *Restoration,* the restorers become part of the 'faux-terrain', and the artist plays with this boundary between the present and the past, between his work and the panorama. The restorers have an almost spiritual presence, and seem to hang around like languid angels, faced with the impossible challenge of redeeming time. Thus Wall's *Restoration,* with its theme of the all-encompassing representation of a historical event, human suffering and the redemption of time, is a study in the limits of depiction. Wall seems to be asking how much content, how much subject matter, how many figures and ideas, an artist can stuff into a picture before the whole thing breaks

Kasimir Malevich
DYNAMIC SUPREMATISM 1915 or 1916
[45]
Oil on canvas
80.3 x 80 (31 5/8 x 31 1/2)
Tate

Paul Strand
ABSTRACTIONS, TWIN LAKES,
CONNECTICUT 1916 [46]
Silver-platinum print
32.8 x 24.4 (12 x 9 5/8)
The Metropolitan Museum of Art.
Ford Motor Company Collection,
Gift of Ford Motor Company and John
C. Waddell, 1987

down aesthetically. In other words, what are the limits of figurative art and where might the artist find that still point of a good picture?

Diagonal Composition 1993 (fig.47) was made within a few months of *Restoration* yet the two pictures are worlds away in terms of scale and subject matter. *Diagonal Composition* is a fraction of the size of *Restoration,* and its content is reduced to a tiny patch of insignificant space: a worn-out sink, a cracked bar of soap and some filthy surfaces. Wall took *Diagonal Composition* in the basement of his studio, where the soap and sink had remained unchanged since he bought the building a few years before. In some ways, it brings to mind *Some Beans* and *An Octopus*. But with *Diagonal Composition,* the 'subject' seems tangential, almost irrelevant (the title alone suggests that we should look at the sink as something other than just a sink). Wall seems to be asking the opposite question to the one he asked with *Restoration:* how much can a picture be reduced before it fails? Does it need a subject, and therefore a theme, in order to succeed? Does it need to represent something? The title also brings to mind the small abstract pictures, made under the banner of Suprematism, just over twenty years after the Bourbaki panorama was finished, by the Russian artist Kasimir Malevich, along with compatriot El Lissitzky. Paintings such as Malevich's *Dynamic Suprematism* 1915 or 1916 (fig.45) were constructed from overlapping geometrical forms and diagonal lines. If we were to eliminate the recognisable elements in *Diagonal Composition* and reduce the soap, sink and counter to formal qualities only, the photograph would take on the appearance of an abstract painting. For Malevich, Suprematism pointed to a new, spiritual reality, and abstract paintings could act like icons of higher consciousness. If the Bourbaki

Panorama tried to fit too much reality into one artwork, Malevich's Suprematism overloaded the symbolic potential of his pictures. In the former, we encounter an immense simulacrum of a historical event, while the latter tries to represent infinity with a few marks on a canvas. Wall plays with this high modernist idealism, but collapses pure form into the mundane filth of everyday. *Diagonal Composition* concentrates the portal of infinity into a banal, utilitarian corner of the world, and thus questions to what extent ideas are inherent to a picture or a kind of supplement provided by the spectator.

The transcendental ambitions of modernist abstraction were not limited to painting: photographers such as Ansel Adams, Frederick Sommer and Paul Strand played with similar ideas. Strand's *Abstractions, Twin Lakes, Connecticut* 1916 (fig.46) stunningly brings to mind both a Suprematist abstract and Wall's *Diagonal Composition*. Alfred Stieglitz, moreover, created a series of 'Equivalents', photographs of the clouds that were meant to reflect spiritual states ('equivalent' to an emotion). But the strength and limitation of photography is the same thing: a photograph can never fully escape depiction. With one glance at *Diagonal Composition* you will seize on the subject: a sink and its surroundings. Even though the experience of looking at the picture will extend to the worn-out setting and the sensations produced by the sharp angles and colours, *Diagonal Composition* will always be a picture of a sink even while asking us to consider its relation to abstract art. Stieglitz's 'Equivalents' emphasised the metaphorical potential of photography: he wanted his pictures of clouds to be ideas first. Wall, on the other hand, plays with the ramifications of these ideas – both in painting and photography – to create a vibrant dialogue between representation and abstraction.

DIAGONAL COMPOSITION 1993 [47]
Transparency in lightbox
40 x 46 (15 ³/₄ x 18 ¹/₈)
Edition of 10

A HUNTING SCENE 1994 [48]
Transparency in lightbox
167 x 237 (65 3/4 x 93 1/4)
Edition of 2

Nicolas Poussin
LANDSCAPE WITH A MAN KILLED BY
A SNAKE 1648 [49]
Oil on canvas
119.4 x 198.8 (47 x 78 3/4)
The National Gallery, London

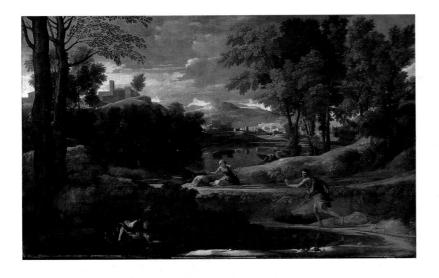

In fact, the limits of representation occupied Wall's mind over the next few years, and 'Diagonal Composition' could equally serve as the title for *Park Drive* 1994 (fig.42), *Swept* 1995 (fig.43) and *Sunken Area* 1996 (fig.54), all images that play with the visual language of abstraction. But these three works assert themselves as depictions of something more strongly than *Diagonal Composition*. Wall may be suggesting that abstraction is an unfinished idea, that it cleared a space for artists in the twentieth century but that as a project it is insufficient, and failed to fulfil the teleology announced by Clement Greenberg and Ad Reinhardt (who claimed that his abstract black paintings would be the last anyone would ever paint). But artists such as Barnett Newman and Donald Judd also taught us that abstract art can achieve a kind of universality in terms of how spectators experience a picture, how shapes and scale tend to have an ineffable effect on our bodies. They also taught us that while the forms of abstract art may not catapult us into a higher consciousness, as Malevich imagined, they can act as metaphors for scales of comprehension, that a fragment – of a colour or shape – can suggest something vast, or an occluded unknown space in a picture can make the viewer feel an absence.

But figurative painters can be equally adept with space. In Poussin's *Landscape with a Man Killed by a Snake* 1648 (fig.49), awareness of the central drama ricochets outward, in a kind of zig-zag motion, from a man who witnesses the horror, to a woman who reacts to the witness, to some oblivious fishermen, to a pool of still water, unruffled by the drama in the foreground, reflecting the background architecture. And this kind of potent, overlapping space is deployed with delicate skill in Wall's overtly figurative work. He uses the evocative potential of

A FIGHT ON THE SIDEWALK 1994 [50]
Transparency in lightbox
189 x 303.7 (74 3/8 x 119 5/8)
Edition of 2

UNTANGLING 1994 [51]
Transparency in lightbox
189 x 223.5 (74 3/8 x 88)
Edition of 2

spatial ambiguity and fragments in a group of pictures that were all taken in the same year: *A Hunting Scene* 1994, *A Fight on the Sidewalk* 1994, *Insomnia* 1994 and *Untangling* 1994. Each of these works feature men who seek something that, in the false eternity of the picture, eludes them. The hunters, curiously heading towards a suburban neighbourhood, have yet to bag their prey; the fighters, and their one-man audience, must still conclude their struggle; the insomniac is recumbent in his sparse kitchen, eyes wide open; and the mechanic sits slumped in front of a massive, intractable knot of ropes.

Importantly, the narrative of each picture is next to impossible to ascertain. We cannot know what, exactly, is going on. Thus the essence of these pictures is not narrative but a structure of pictorial and abstract elements. And humour, the reliable companion of uncertainty, lightens the mood. In *A Fight on the Sidewalk* (fig.50), everyone is so motionless they look stuffed, like specimens in a diorama. The graffiti in the background – someone's attempt to make art, however scrappy and modest – reminds us that everyone strives, in some way, to assert their subjectivity. The man in *Insomnia* (fig.52) (his kitchen is an exact replica of the kitchen in Wall's studio) sweats beneath the table, surrounded by cupboards, a window, various spaces that open and close as if to offer escapes into sleep, and the brown bag in the upper right of the picture looks as if it has been captured mid explosion, perpetually popped by an unseen power in order to keep him awake. The hunters seem absurdly out of place, rooting about in a city for unseen game. *Untangling* (fig.51) is a more melancholy picture, the mechanic slouching in heavy-hearted anticipation of the impossible task he faces. Meanwhile, in the background, his colleague goes about his business. Because of their ambiguity, the

pictures are full of metaphorical potential, but would be less interesting as photographs if they looked like purely metaphorical spaces. They must be plausible, recognisable as something you might come across any day; abstraction, and meaning, must not override the filth of the sink.

Talking about *A Hunting Scene* (fig.48), Wall describes the importance of balancing plausibility with an unseen, abstract quality:

I knew that any image of men carrying guns in a suburb can't be seen as just self-evidently a picture of men hunting animals. I knew that there would be ambiguity. The setting is evidently a farming area quickly becoming a suburb. There are still people living there who hunt raccoons or other animals they consider pests. That can be understood easily. But you cannot legislate that scenario in the picture because an alternative one can be established too. Nevertheless, the plausibility of the one I've just told you is undisturbed by any other, and to a great extent the meaning of the picture rests on some minimum plausibility. The scenario needs to be plausible, not certain. If it's certain, it's dull; if it's implausible, it's equally dull.

Looking at these photographs, we, like Wall's protagonists, have a knot to unravel, a dream to experience and some small creature to poach in the back-lots of suburbia. But this must be understood as a form of play rather than a task, an experience of a picture rather than the plucking out of a narrative or a meaning.

Sunken Area 1996 (fig.54) is an exceptionally beautiful picture that sets up a dynamic dialogue between abstraction and figuration. The row of weeds, like the intricately detailed yet almost cartoon-like foliage in the foreground of a Botticelli painting, is unmistakeably figurative; the white slats of the wall seem to conceal what might normally be the content of the picture. Wall has commented that 'every picture

INSOMNIA 1994 [52]
Transparency in lightbox
172.2 x 213.4 (67 3/4 x 84)
Edition of 2

Edward Weston
BENCH (COMICS, ELLIOT POINT) 1944
[53]
Photographic print
19.3 x 24.4 (7 5/8 x 9 5/8)
Collection Center for Creative
Photography, The University of
Arizona

can be thought of as a model of what a valid picture is', and *Sunken Area* is a kind of open-ended discussion about the power and limits of abstraction and figuration. Although the top section of the work immediately brings to mind the meditative abstracts of Agnes Martin, a more fertile contrast is provided by Edward Weston's photograph *Bench (Comics, Elliot Point)* 1944 (fig.53). The foreground weeds and the horizontal lines of the bench match the composition of *Sunken Area*, but the pictures differ in crucial ways. Weston's photograph has a subject: a beaten-up bench against a stone wall. He locates a kind of sentimental beauty in the forms of the bench and the textures of the wood, stone, grass and a comic book. Our feelings about the objects depicted dominate our perception of *Bench,* whereas *Sunken Area* creates a precarious balance between abstraction and representation. As in a Martin painting or other object of contemplation, many ideas will emerge and perish through the mesmerising structure of the work. Considering how accustomed we are to looking at photographs in order to find a quick and easy story or theme before looking away, this is Wall's triumph: to get us to look again, not to see something familiar, but because we feel compelled to do so by pictorial beauty.

Wall has spoken about how 'the beauty of an image derives in part from the fact that we never know exactly what we are feeling when we look at it'. What do we feel when we look at *Park Drive* 1994 (fig.42)? The picture is constructed from the lines of towering trees and a zip of road and sky, and it owes much of its success to the fact that is not just a landscape but also, with its flattened space and resulting colour fields, a powerfully abstract picture. Immediately, we encounter the park drive – a road through a Vancouver park with its typical combination of sword ferns, berry bushes, cedars and firs. At the vanishing point,

where the sky meets the road, we can see a tiny car, a detail not unlike the figure in *Steves Farm, Steveston.* This is the still point of the picture, where depiction and abstraction collide, freeing the viewer's imagination to treat the work as either.

If the Bourbaki panorama overshoots the limits of representation, Malevich's black square probably exaggerates the potential of abstraction. Many of Wall's photographs during the mid-90s explored the in-between space, hoping to balance the two in order to find the still point of a good picture. *Sunken Area, Park Drive* and *Insomnia,* among others, give us some idea of where to find it.

SUNKEN AREA 1996 [54]
Transparency in lightbox
218.2 x 274 (85 7/8 x 107 7/8)
Edition of 2

Odradek is a character in Kafka's short story *The Cares of a Family Man,* a small creature that inhabits domestic spaces, both a metaphor and a living thing, an abstraction and an object. Kafka describes him as:

a flat star-shaped spool for thread, and indeed it does seem to have thread wound upon it; to be sure, they are only old, broken-off bits of thread, knotted and tangled together, of the most varied sorts and colours. But it is not only a spool, for a small wooden crossbar sticks out of the middle of the star, and another small rod is joined to that at a right angle.

The Odradek that Wall built to make this picture still lurks in a corner of his pristine studio. In the photograph, Odradek is barely visible between the staircase and the wall, located almost exactly in the centre of the picture. He could act as the 'still point' of the picture described in the previous chapter, but the power of the photograph emerges from the proliferation of overlapping spaces and unseen things.

CRAIG BURNETT: When did you read the Kafka story and what led you to make a picture about it?

JEFF WALL: *I read the Kafka years and years ago, perhaps as early as the 60s, and it's just very familiar to me. And at some point it just popped into my head to do that picture, to play a game: I'll go to Prague hunting for Odradek and get a snapshot of him in a stairway, since he is most likely to be spotted in stairways. If Odradek had survived the Holocaust (and I think he is one of those most likely to have done so) he'd be hanging around where he always hangs around. He wouldn't have gone any- where. I thought that if I kept going to the same area, I'd find him eventually. If I went to the right staircase, he'd eventually pop up. I wanted the picture to be a photograph done as if I were visiting Prague and I got a glimpse of him in the stairs, there in the shadows, barely noticeable. So I went to Prague in the winter of 1993 to see what I'd come up with. I started going up and down streets poking into doorways and the entrances of apartments, and many were unlocked. We could just walk in. I took snapshots of many foyers and staircases. They were old, fairly decrepit, but beautiful, and revealing of the way people were living just four years after the Wall came down.*

CB: So the initial impulse sounds quite light-hearted.

JW: *As light-hearted as Odradek himself. I think it's in keeping with Kafka's way of writing.*

CB: How did you construct Odradek?

JW: *I just read the description carefully. Kafka describes him very meticulously, so you just have to pay attention.*

CB: And in the picture he's around the corner waiting for the girl to descend.

JW: *He's just lurking, as he always does.*

CB: Odradek responds to a question about where he lives with 'No fixed abode!', which is comic because it's so understated, and this little talking thing is absurd. But he also seems to have a deeply serious role as a metaphor for the futility of trying to locate the origins or ends of human culture.

JW: *Odradek tells us nothing somehow, but I'm always curious what he's up to.*

CB: The picture has what I might call a signature of your photography: hidden spaces and other rooms.

JW: *Things unseen. Yes, I love that feeling and I often try for it. I think pictures are made up of their visible and their unseen parts. One of the marks of a good picture is that the unseen parts resonate inside it so that you imagine their unseen-ness.*

CB: What about the girl descending the staircase. You weren't making any jokes about a nude descending a staircase, no allusions to Marcel Duchamp or Gerhard Richter?

JW: *I don't make those kinds of jokes. If a girl's descending a staircase, a girl's descending a staircase. Just because she's coming down a staircase doesn't mean I am referring to anything. If people want to think of it in those terms, then that's their affair. Depiction just causes things to resemble each other. I didn't want her going up the staircase, because I didn't want her seen from the back. If I want to relate to other pictures I do it straight up like in* A Sudden Gust of Wind.

ODRADEK, TÁBORITSKÁ 8,
PRAGUE, 18 JULY 1994 1994 [55]
Transparency in lightbox
229 x 289 (90 x 113 3/4)
Museum für Moderne Kunst,
Frankfurt am Main

VOLUNTEER 1996 [56]
Silver gelatin print
221.4 x 313 (87 1/8 x 123 1/4)
Edition of 2

CITIZEN 1996 [57]
Silver gelatin print
181.2 x 234 (71 3/8 x 92 1/8)
Edition of 2

SPACE, FATE AND DEMOCRACY (1996–9)

In 1996, after about twenty years of working exclusively in colour, Wall made the seemingly backwards move to black and white photography. Why the sudden turn? In fact, he had been interested in making black and white pictures for many years, but was hindered by a technicality: he wanted to print these pictures himself, but didn't have the means – a dark room of sufficient size to make large-scale prints – until the mid-1990s. He views colour and black and white photography as different aesthetic experiences, though not fundamentally different forms of picture-making. And although he worked, as usual, with actors and collaborators the photographs are marked by a casual, snapshot appearance, an intentional air of realism. He wanted to play with ideas of 'authenticity' associated with black and white photography. 'Part of my interest in taking up black and white photo-graphy', he comments, 'was to rethink my relation to the documentary tradition. Or, maybe more precisely, to the assumption that uncoloured photographs signify something we call "documentary"'.

The tradition of documentary photography, moreover, tends to claim a greater theoretical facility than colour, a sense that it is revealing a truth beyond appearances rather than just registering a prosaic visual experience. When we want the unembellished truth, we say 'give it to me in black and white'. Black and white is news, hard facts and philosophy, whereas colour is garish, fake – the back-lit adver-tising photograph or the family snapshot. Bernd and Hilla Becher, probably Europe's most influential photographers and teachers of photography during the 1970s and 1980s, work only in black and white and even discouraged Andreas Gursky, their most famous pupil, from using colour. (Wall, ironically, became an important influence on Gursky during his early forays into large-scale colour photography). In the mid-

1970s, Americans such as Stephen Shore and William Eggleston, who had an important show at MoMA, New York, in 1976, helped to bring about greater art-world acceptance of colour photography. So although Wall may not adhere to any narrow division of purpose between black and white and colour photography, black and white, in the popular imagination, at least, seems to possess a stronger whiff of solemnity. Part of his challenge was formal: could he make successful monochrome photographs after creating a signature style with his brightly coloured, back-lit transparencies? (The black and white photographs are printed on paper rather than back-lit.) A change in format also prompted a change in theme: Wall used these pictures to examine how spaces and environments reflect aesthetics and morality in a contemporary democracy.

In *Passerby* 1996 (fig.58), the atmosphere is charged and fugacious. The brilliant flash lends journalistic immediacy to the scene, as if a paparazzo had snapped a shot after sneaking up on a politician or a crook. The severe lighting may also bring to mind the headlights of a car illuminating an accidental encounter. (In fact, the process was anything but quick: Wall selected this picture from over 200 takes, made during about two weeks of shooting.) But what can we really conclude from the scene? Two men pass each other, ships-in-the-night style, and the man in the foreground glances over his shoulder at the man who seems to be fleeing the scene. The flash creates a shadow of his hand in the shape of a comically huge phallus on the wall behind him. Is that an accident, or is Wall inviting us to imagine that he is the perpetrator of a sex crime or contemplating a sexual encounter? The illuminated STOP sign is almost exactly the same size as the man's head, and these two maculae create anchor points for the composition (like

PASSERBY 1996 [58]
Silver gelatin print
250.2 x 339.6 (98 ½ x 133 ¾)
Edition of 2

CYCLIST 1996 [59]
Silver gelatin print
229 x 302.7 (90 x 119 ⅛)
Edition of 2

the two towers in *The Holocaust Memorial in the Jewish Cemetery*). Because of the lighting, the mood, and the black and white format, we might expect this picture to be a glimpse of something illicit. But if we look again, we see that while tension, both thematic and pictorial, keeps the photograph tight and bound up in a kind of potential energy, there is little reason to conclude that anything corrupt is going on.

On the contrary, the set of black and white photographs that Wall made in 1996 are as much about virtue as they are about vice; the pictures toy with our temptation to assume that the world depicted is dark and irredeemable. *Volunteer* 1996 (fig.56) is the first black and white picture that Wall made, and also one of the more affecting works from this period. The success of the photograph depends upon the tension between the scene of a man mopping the floor in a dimly lit, shabby room and the immense picture on the wall that depicts an idealised mountainous landscape replete with butterflies and birds. The photograph is beautifully composed: the white of the man's T-shirt echoes the patch of snow on the mountains, the mop handle reflects the trees, and the damp mop head, an organic form, soppy with water, is a counterpart to the lake in the picture. In the background, beside the cluttered sink, three stuffed-animal toys, those little depositories of affection, hang on a pipe like fresh game. Wall contrasts a kitschy vision of pristine, harmonious nature and its promise of happiness with a mundane activity: the cleaning and maintenance of a public space. Although the picture conveys a feeling of entrapment and joyless labour, it is, for Wall, an image of virtue:

[Volunteer] shows a young man working late at night in what we call a 'drop in centre'. Those places are established sometimes by a church, sometimes by civic organisations, sometimes just by philanthropists, to provide a place where people with nowhere else to go can come and find some shelter, get information or maybe advice, can maybe get something to eat or drink, or simply to find a little company and get away from the dangers of the street. Often, the places are run by unpaid volunteers. Volunteer work has something enigmatic about it, in relation to a world dominated by the principle of exchange and paid employment ... I know that these places are maybe far from happy, but they are what is actually possible, under the circumstances.

A resting place for the forlorn and homeless, probably in the basement of a ramshackle building in a modern city, is a site of positive, meaningful activity, whereas the ostensibly beautiful wilderness is a false promise. But the formal links between the worlds – the clean T-shirt like mountain snow – prevent us from being too narrow in our assessment. The two worlds create each other. The mountain wilderness is also, like the Eiffel Tower, Big Ben or the White House, an icon of local identity, a reflection of the self-image of many British Columbians. In a land with so little human history and with a culture of bewilderingly mixed heritage, natural history replaces myth. *Volunteer* creates a dialogue between these two spaces. By moving back and forth from interior to exterior, ideal to real, kitsch to squalor, the picture presents a unified space in which nature and culture are not opposites, but rather complement and inform each other.

Similarly, *Cyclist* 1996, *Citizen* 1996 and *Office Hallway, Spring Street, Los Angeles* 1997 (figs.46, 47, 48) depict men alone in ambiguous situations in which they converse with the spaces they inhabit. Despite the rough, urban spaces depicted in all these pictures, the mood is subdued, a little ethereal, and ambiguous. The man in the Los Angeles hallway looks

HOUSEKEEPING 1996 [60]
Silver gelatin print
192 x 258 (75 5/8 x 101 5/8)
Edition of 2

OFFICE HALLWAY, SPRING STREET,
LOS ANGELES 1997 [61]
Silver gelatin print
195.2 x 226.3 (76 7/8 x 89 1/8)
Edition of 2

JUST WASHED 1997 [62]
Transparency in lightbox
37.6 x 42.3 (14 3/4 x 16 5/8)
Edition of 8

CLIPPED BRANCHES, EAST CORDOVA
ST., VANCOUVER 1999 [63]
Transparency in lightbox
71.8 x 89 (28 1/4 x 35)
Edition of 8

POLISHING 1998 [64]
Transparency in lightbox
162 x 207 (63 3/4 x 81 1/2)
Edition of 2

as if he's arriving at an office to start a day's work. He may appear somewhat downcast, the mirrored walls may create an eerie space, and the hallway doors may possibly conceal, like those in Duke Bluebeard's Castle, murders or other nasty surprises, but they may equally be spaces of rest, meaningful labour or freedom – he has a key in his hand, which will open a door. The man in *Citizen* seems so comfortable in a public space he can rest without fear of violence. He appears to live up to the ideal of what a citizen is: free, not beholden to any sovereign or authority. The *Cyclist* is slumped over the front of his bike, perhaps buckled over in grief or exhaustion. His immediate environment, with its piles of rubbish, the remains of a fire and utilitarian cement wall, is unpleasant and it is not clear what he's doing there. Although the mood of the picture is anxious, the distress we detect emanates from the space itself, not from the cyclist. In fact, his bike, with its two baskets, might suggest that he is collecting things, that he is a volunteer helping to clean up some untidy corner of public space or delivering humble things to local houses. If we think of the cyclist in terms of the role fulfilled by the *Volunteer,* the picture transforms into something gentle and altruistic. We could, of course, assume that he's lost, drunk or otherwise in trouble, but is that any more accurate – or enlightening – than assuming the opposite?

The space depicted in *Housekeeping* 1996 (fig.60), a nondescript hotel room in anywhere-ville, conveys a curiously neo-classical calm. The chambermaid leaves the room, but, like the Volunteer, she is destined to come and clean again. Yet the picture is better understood as a depiction of someone fulfilling a role in the basic maintenance of a room than an image of pointless, Sisyphean labour. She is anybody in a space so banal it has no particularity; global capitalism and

A VILLAGER FROM ARICAKÖYÜ
ARRIVING IN MAHMUTBEY –
ISTANBUL, SEPTEMBER, 1997
1997 [65]
Transparency in lightbox
209.3 x 271.4 (82 ³/₈ x 106 ⁷/₈)
Edition of 2

RIVER ROAD 1994, printed in 1997
[66]
Transparency in lightbox
90.3 x 119 (35 ¹/₂ x 46 ⁷/₈)
Edition of 4

travel – the acceptable face of conspicuous consumption – have made the hotel room a universal experience. But our own apartments often show little individual character. *Polishing* 1996 (fig.64) depicts a similarly nomadic space, but one occupied by a slightly more permanent resident. Here a guy, the universal salesman, tries to polish himself up to look presentable for a day's work. The tools of his trade scrappily decorate the room: a Starbucks paper cup, a diary and/or notebook with a pen next to it, some magazines and newspapers, a pile of binders on the floor, a few cheap suits in the closet. He is trying to get by, and the space he inhabits – messy, patched up and filled with the poignant paraphernalia of stunted ambition – may suggest he's failing, but he is, at least, trying, and this makes his actions virtuous. The space is evanescent, in-between, indicative of change and improvement, however meagre.

For Wall, cleaning and maintenance grace pictures with both moral and aesthetic potential. A straightforward depiction of an object such as *Just Washed* 1997 (fig.62) might be a simple parody of a commercial for laundry detergent, but this everyday towel, grey and stained despite being newly washed, has a wider resonance. The irony of *Just Washed*, obviously, is that the cloth is still dirty, as if even a mundane object like an old towel might hint at humanity's imperfectability (the detergent company, of course, would like us to think otherwise). Equally, *Clipped Branches, East Cordova St., Vancouver* 1999 (fig.63) may look like the aftermath of violence, but it is also a picture that captures a persistent and powerful desire to live (the tree sending out new branches), civic maintenance and healing. These little studies of small spaces are meditations on our desire for perfection and cleanliness in an irretrievably mucky democracy.

Enormous exterior spaces, likewise, offer meditations on the effects of capitalism and democracy. In *A Villager from Aricaköyü arriving in Mahmutbey – Istanbul, September, 1997* 1997 (fig.65), we see a young man, probably not dissimilar in ambition to the man in *Polishing*, leaving his home village to make his way in Istanbul. He is anybody, the itinerant worker, the postmodern peripatetic, and his path is not defined by desire, but by economic necessity. The picture has a fairy-tale quality, with the minarets of the mosque in the background, the intersection faced by the man and the criss-crossing wires like the lines and limits of fate. In the background, a crooked path – strongly redolent of Wall's own *The Crooked Path* – wiggles its way towards the buildings in the distance, a little detail suggesting that his decision to go to Istanbul promises freedom and entrapment in equal measure. About *A Villager*, Wall has said:

Istanbul has been called a 'giant Anatolian village', and there are many other such mega-villages now around the world. They're a new combination of the old urban experience with the new instant postmodern village. Cairo, Buenos Aires, Shanghai, Lima – I could probably have made A Villager *in any of those places, too, and I find that fascinating. Even if emigrants tend to arrive in groups and gather together with their families or people from their home village, I wanted to emphasise the experience of one person, one young person, arriving in a new place, so I set him by himself, coming in along the road … I didn't want to show the arrival of a defiant, angry, suspicious and anxious young man, though there are, of course, any number of those.*

River Road 1994 (fig.66) could be considered a counterpart to *A Villager*. It has the same sense of space, but it only implies a human presence, and

PEAS AND SAUCE 1999 [67]
Transparency in lightbox
49 × 61 (19 3/4 × 24)
Edition of 8

depicts the property of someone who seems not to be striving for anything. Despite the derelict greenhouse, this house and its environs appear unlikely to be a working farm. Everything looks ephemeral, as if it could be swept away with little consequence, and yet the impression is of paralysis. Modernity, if not life, is elsewhere. An old postal truck, one of at least five old and probably neglected vehicles, is parked behind the house, either a sign that the resident collects old trucks or that he may have been employed by the Postal service many years ago. A big black dog rests beside the house. In the background, a long, thin strip of grey, a freight train, creates a soft, artificial horizon. The telephone and electrical wires break up the pictorial space and also evoke the thousands of messages, and therefore lives and possibilities, zipping back and forth above the house. The structure of the photograph invites us to enter it, past the road, under the wires, behind the house: typically for Wall, the work is powerfully kinaesthetic, structured with seen and unseen spaces and composed with a strikingly cool palette of greens and whites. We may detect a stultifying apathy in this scattered space, but there is also something homely and comfortable about the setting. Wall has found a subtle beauty here.

But surely this is an ugly space – a chilly, neglected corner of Vancouver, probably inhabited by a grumpy nobody? Although many of Wall's pictures from this period, both black and white and colour, depict forlorn and alienating things, places and people stripped of particularity by failure or impersonal economic forces, it would be too easy to dismiss them as a way of expressing only disgust or melancholy about the world. Take, for instance, *Peas and Sauce* 1999 (fig.67). This takeaway meal looks thoroughly jilted. It is perhaps the kind of meal our man in *Polishing* might eat in his car before discarding the

aluminium tray on the road. Wall's technique was similarly throwaway – according to the artist, the picture took 'ten minutes'. And yet the range of textures coupled with the low perspective, as if Wall fell to the pavement to take the photograph, make this metallic oyster with little green pearls a compelling piece of trash. Our reaction to it is both moral and aesthetic. For Wall, these overlooked spaces and objects display a kind of flawed, democratic beauty:

I don't think I'm interested in ugly environments. That suggests an aversion. In the Christian world, the ugly contains a suggestion of evil. I may be interested in that from time to time, but I'm more interested in the commonplace or the everyday, in imperfections. Walt Whitman, in Democratic Vistas, *defined the essence of an ambitious, secular, modern and democratic art form as fundamentally involved with imperfection, because life is always imperfect. And one of the great processes carried on in modern democratic society is that in which people learn to come to terms with imperfections in themselves and others. So I think the commonplace has an enormous charge on an artistic level because it ruins the old rigid hierarchies of art and lets new feelings emerge. I think by working with that it is possible to create a new feeling of the beautiful – one that is refreshed.*

The 'Barcelona' Pavilion was designed by Mies van der Rohe as the German National Pavilion for the Barcelona International Exhibition, 1929. When the exhibition closed in 1930, the Pavilion was disassembled. However, over the course of the twentieth century, it became a touchstone and emblem of the Modern movement. Because of its cultural significance, the Barcelona City Council made the decision to reconstruct the Pavilion in 1980, re-opening it in 1986.

CRAIG BURNETT: What interested you about taking a picture of the Barcelona Pavilion?

JEFF WALL: *I had initially planned to do a picture in a private house outside Paris, of a cleaner washing the windows. But that didn't work out because the owner didn't want the house seen in those terms. Then by coincidence I was invited to do a show at the Barcelona Pavilion – the most famous glass-walled structure in the world. Since there is almost nothing an artist could add to that space, for the show I just placed the little sculpture of Odradek I had made for my Prague picture behind the curtain in the Pavilion, as if he were hiding there. I thought it was amusing, but also interesting, to bring these two things together because they represent such different notions of space. But doing the exhibition was also a way to obtain the co-operation of the foundation that manages the pavilion in making the picture there. The original subject was the maintenance of the transparency of glass architecture through the labour of cleaning, mainly cleaning the glass, but not just cleaning the glass. It clearly related to other pictures with the same or nearly the same theme, like* Volunteer, Housekeeping, *and a few others.*

CB: Is it the idea of maintenance that you like?

JW: *It's to do with virtue. It's about what we have to do to be virtuous. This connects modernity and modern architecture with nature, since it's nature that makes glass dirty. Cleaning is mysterious, since it is the labour that erases itself if it is successful. The man in the picture is the real cleaner. The picture is documentary in the sense that that's exactly what he would be doing at that moment of the day. It's what I call 'near documentary'. Although I arranged the picture and worked in collaboration with the cleaner, the picture resembles very closely what a snapshot made at that moment would show.*

CB: But you chose the angle from which to shoot the picture.

JW: *There are about fifteen standard pictures of the Pavilion, all taken from what seem to be cardinal points. If you move away from those points, the building is just as*

good but the pictures of it don't seem to be. One of the cardinal points is about five inches from where I took my picture. I just slightly inflected the standard view.

CB: What about the car just visible on the right? You could have excluded it, presumably.

JW: *You can see the nearby road through the front glass, on an angle, and you can see the road that goes by, and there was a car and some other everyday things visible out there. It's complex in that corner and I like that zone quite a bit. There was no reason to exclude the glimpse out through the glass.*

CB: The interior has an ageless quality and probably won't look out-of-fashion or obsolete in a hundred years, but the car will date the picture.

JW: *Yes, that's right. It will be an old photo one day with an ancient car in the corner.*

CB: Did you direct the cleaner?

JW: *Yes. But first I had to learn what he normally does. I didn't change anything, just watched it carefully and found the moment I thought made the best picture.*

CB: Did you want the soap patterns on the glass to rhyme with the patterns in the marble?

JW: *Well, the soapy water makes natural patterns, so it's related whether I want it to be or not.*

CB: What interested you about cleaning a glass house and how that might relate to the maintenance of modernist or avant-garde aspirations?

JW: *I don't really care about that. My picture isn't an answer to that question. It's just a depiction, a way to look at the world. He's cleaning because that's his metier, that's his job – he cleans because he's employed to clean. We find it reprehensible to go into a dirty interior, even though we might live in one. Living in a dirty interior – or, creating a dirty interior space – is a statement of some kind, which is one of the reasons why we like to see pictures of dirty interiors so much, why such spaces are so photogenic. Mies and his colleagues were very sensitive to these meanings, and their buildings require an especially scrupulous level of maintenance. In more traditional spaces a little dirt and grime is not such a shocking contrast to the whole concept. It can even become patina, But these Miesian buildings resist patina as much as they can.*

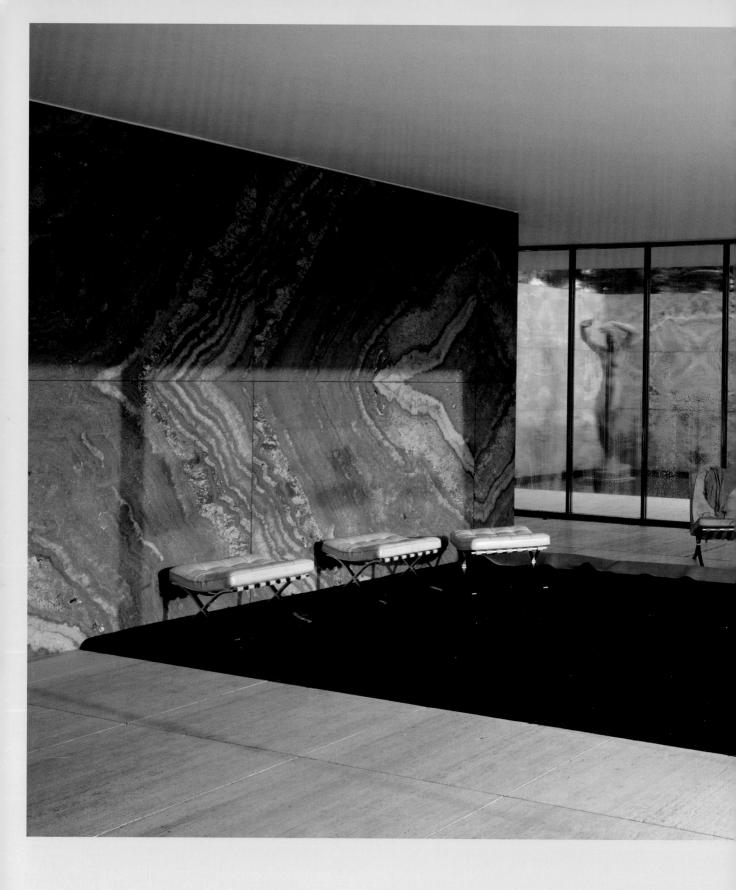

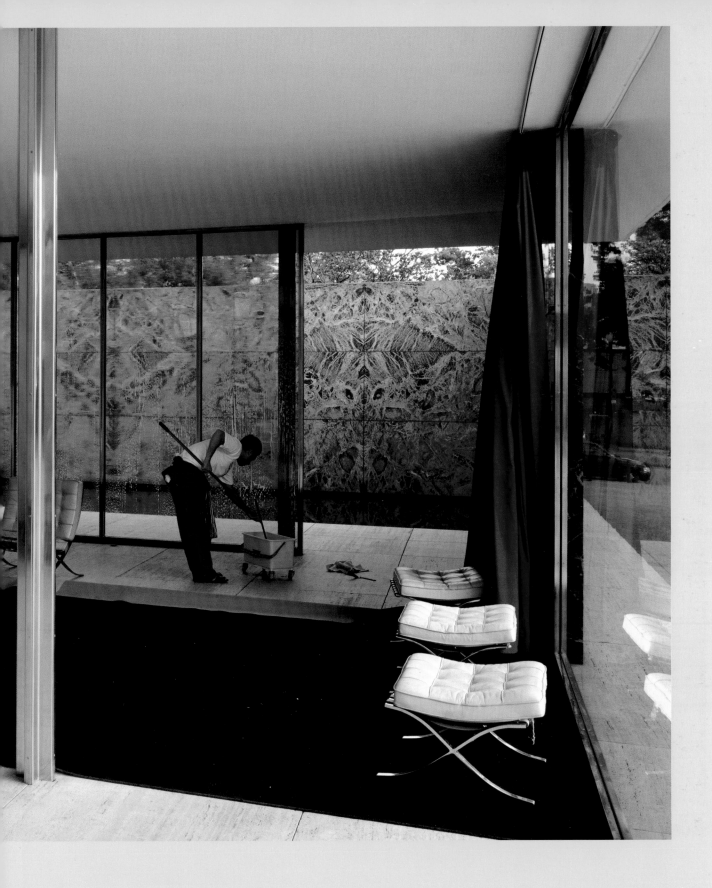

AFTER 'INVISIBLE MAN' BY RALPH
ELLISON, THE PROLOGUE
1999–2000, printed 2001 [69]
Transparency in lightbox
174 x 250.5 (68 ½ x 98 ½)
Edition of 2

BLIND WINDOW NO.1 2000 [70]
Transparency in lightbox
109 x 133 (42 $^7/_8$ x 52 $^3/_8$)
Edition of 5

INVISIBLE CHIMERAS (2000–PRESENT)

*Is it possible that in all the time you have travelled with
me you have not yet noticed that all things having to do
with knights errant appear to be chimerical, foolish,
senseless, and turned inside out?*
Miguel de Cervantes, *Don Quixote* (1605)

In December 1999, *ARTnews* magazine included Jeff
Wall in a list of the 'Ten Best Living Artists' (Cindy
Sherman was the only other photographer to make
the cut). Whether the list reveals anything about the
state of contemporary art is open to debate, but it did
offer some measure of what Wall had achieved in just
over twenty years. His success meant that he could
give up, as he says, 'the office politics of academia' and
quit his teaching position at the University of British
Columbia. The departure from the academy after
about thirty years as either a student or professor
seemed to set off an even stronger interest in the life
of the mind. Wall has always explored social spaces
in his work, and many of his pictures turn, with a
deft tweak of our perception, a slice of everyday
life into a snippet of myth. Increasingly for Wall, in
both his documentary and cinematographic work,
a picture became a way to register a state of mind or
open a crack that leads from the photograph's surface
to another, invisible reality. At the same time, he
never abandoned the plausible surface of the
photograph.

In contrast to the stark, black and white
photography that Wall had pursued for a few years
after 1996, he now embarked on two lush and
multifaceted tableaux: *After 'Invisible Man' by Ralph
Ellison, the Prologue* 1999–2001 (fig.69) and *The
Flooded Grave* 1998–2000 (fig.79). *After 'Invisible
Man'* is, like *Odradek, Táboritská 8, Prague, 18 July,
1994* (fig.55), a photograph based on a story that the
artist had known for many years. An element of

pilgrimage had inflected the process of taking
Odradek, and Wall also travelled to Harlem before he
began photography of *After 'Invisible Man'*, studying
and taking pictures of about a dozen cellars in the area
in order to ensure the historical authenticity of every
detail. He then built the elaborate set in his Vancouver
studio. Unlike the room in *Polishing* or *Volunteer*, this
space, though historically accurate, suggests the self-
constructed universe of a fictional character. The dirty
realism of *Polishing,* in which the objects in the room
reflect a man's daily life and aspirations, has been
replaced by a more dreamlike, introspective mood.
The interior space here hints at the social status of the
protagonist, to be sure, but it also evokes his
consciousness.

The novel *Invisible Man* is written from the point
of view of an African-American man who lives in
Harlem, New York and feels invisible because of his
race and social status. As a kind of consolation, he fills
his basement apartment with 1,369 light bulbs. 'Light
confirms my reality', writes the narrator, 'gives birth
to my form. Without light I am not only invisible, but
formless as well, and to be unaware of one's form is to
live a death.' In the popular imagination, the 'pop' of a
light bulb represents the birth of an idea, often
bursting into the headspace of cartoon characters to
suggest an epiphany. Although the narrator may feel
invisible socially, he has constructed a dwelling that
reflects his interior life: dry, delicate, tactile, warm
and humming with light, energy and ideas. He is not
unlike a homunculus, the 'little man' who, according
to a few obsolete theories of consciousness, managed
the human mind. He sits within his self-composed
space, in control of the synapse-like light bulbs, as if
by turning them on or off he can express his thoughts.
He is, moreover, a writer: while washing the pot in
his hands, he glances at his manuscript. Like a

OVERPASS 2001 [71]
Transparency in lightbox
214.2 x 273.3 (84 3/8 x 107 5/8)
Edition of 2

RAINFILLED SUITCASE 2001 [72]
Transparency in lightbox
64.3 x 79.8 (25 3/8 x 31 3/8)
Edition of 8

photographer, he creates, with light, an imaginary world of beauty and meaning.

Blind window no.1 2000 (fig.70) closes the external world off altogether, creating a starker, even more introspective space. Windows, of course, frame the outside world, and thus have always made useful metaphors for painting and photography. (What we see through a window is not a theatrical presentation, but what's going on anyway, which is partly how Wall defines his 'documentary' photographs.) But *Blind window no.1* is like the view from behind an eyelid. The opaque window creates an interior space in which we must imagine not just a fragment of the external world, but build our own image of it entirely. *Blind window no.1* relates to photographs such as *Diagonal Composition* or *Sunken Area;* on one level, they are studies of small, overlooked spaces, but they also flirt with abstractions to create an atmosphere in which the unseen is a tangible, concentrated thing. *Blind window no.1* also brings up the possibility of an art cut off from a mimetic or representational model. Rather than frame a view of the outside, *Blind window no.1* transports us into an interior world, where everything might be chimerical, foolish, senseless and turned inside out.

Don Quixote, in his charming madness, saw the helmet of a legendary knight in a humble barber's basin. In the same way, part of the pleasure of Wall's humdrum scenes is that they might unlock a vast metaphorical potential in everyday imagery. *Overpass* 2001 (fig.71) is a gruff street scene redolent of Wall's earliest work, such as *Mimic*. But if we compare *Overpass* to *Mimic,* the scene is at once more mundane – there is little tension – and more subtle and evocative. A group of four people (the fourth is barely visible behind the man on the right), heavily burdened by luggage, walks away from the

photographer, whose presence is implied and whose position we share. On the level of everyday plausibility, we are in familiar Wall territory: the landscape is urban, anonymous and not particularly appealing, the protagonists are neither comfortably middle-class nor utterly destitute and a number of plausible scenarios might explain their behaviour. So nothing unusual is afoot. The photograph is beautifully constructed from a palette of cool greys, blues and other dampened hues. The sense of almost infinite distance, suggested by the shrinking streetlamps – those stalwart Wall motifs – and the clouds and mountains in the background, creates a mood of pilgrimage, as if these four travellers were setting out on an endless journey.

But *Overpass* has more to say about an emotional condition than a trip, real or imagined. It could almost be an illustration of a turn of phrase: the travellers are carrying a lot of 'baggage' or have 'a monster on their backs'. In Baudelaire's marvellous prose poem *To Every Man his Chimera* (1860), the speaker describes how he encountered, 'under a vast grey sky', 'several men bent double as they walked' and 'each one carried on his back an enormous Chimera as heavy as a sack of flour'. The Chimera is a 'ferocious beast' that clings to the men, and yet they seem not to show much concern about its presence: 'And the procession passed by me and disappeared in the haze of the horizon just where the rounded surface of the planet prevents man's gaze from following.' *Overpass* is not, of course, an illustration of *To Every Man his Chimera*, but if we allow ourselves to read the picture like a prose poem, then the photograph's everyday details become more suggestive, inviting us to find in the gorgeous, melancholy surface a hint of deep feeling. The pilgrims have chimeras to tow across a mundane overpass; they may be weighed down by guilt, by

CUTTINGS 2001 [73]
Transparency in lightbox
115.3 x 143 (45 3/8 x 56 1/4)
Edition of 8

regret, by age, by pride, by whatever. But they carry on, climbing towards the point where the rounded surface of the planet – the overpass – makes them invisible.

One of these weary travellers might have tossed aside his chimera to create the scenario we encounter in *Rainfilled suitcase* 2001 (fig.72). Wall happened across this assortment of objects in the alley behind his studio and took the picture immediately. But why would a busted, abandoned suitcase cradling a few centimetres of rainwater and surrounded by detritus – some fast-food cups, a condom wrapper, an envelope and a grape stem among other things – interest the artist? If we remember *Peas and Sauce,* we recall that Wall is interested in these flawed fragments of everyday life because they express the fractured nature of beauty in a democracy. The small things that surround the suitcase echo beyond and suggest the half-forgotten details of someone's life. But Wall has also written about water as having a 'liquid intelligence' that links it to old processes 'a sense of immersion in the incalculable' (like the explosion of fluid in *Milk*). This he distinguishes from the '"dry" character of the institution of photography'. 'In photography', he concludes, 'the liquids study us, even from a great distance'. This suitcase, this forsaken chimera, overflows with incalculable rainwater, returning Wall's gaze as if to say: 'There are more things in heaven and earth, camera, than dreamt of in your lens.' The water in the suitcase is like the chimerical consciousness of the passerby – or petty thief – who abandoned his belongings. It is also the subjectivity of Wall's audience. So the suitcase is at once a container for liquid intelligence and the baggage, the limitless thoughts and contributions, that viewers bring to their perception of Wall's pictures. Nature overflows in incalculable ways and

viewers bring their chimeras to each picture; *Rainfilled suitcase* expresses this condition of art and photography.

The complexity of subjectivity is also suggested by *Forest* 2001 (fig.75). The picture confronts the viewer with a profuse web of branches in which trees lose their individual identities and become part of a single, impenetrable mass. Barely visible at the left of the picture, a man seems to be waiting for his companion, who walks away from a small encampment. We cannot know if the figures have disturbed the scene or if the implied presence of a viewer – and the photographer – has disturbed them. We could even look at the pot and its rising steam, another image of liquid in all its incalculability, as the focus of the picture. Beside the pot, a collection of branches, a small piece of order wrung from chaos, rests on a piece of wood. This little cluster of twigs looks forward to *Cuttings* 2001 and *Logs* 2002 (figs.73, 74). Both these pictures are counterparts to *Forest* insofar as they present wood – and therefore nature – as a conquered object for human use. In their discipline and calm, *Cuttings* and *Logs* may bring to mind *Adrian Walker, artist. Forest*, on the other hand, is more likely to recall one of Wall's 'filthy interiors'. The inscrutably complex network of branches forms an image of the forest-dwellers' sense of entrapment or confusion. *Forest* and *Logs,* in their complementary depiction of chaos and order, represent two states of mind.

With a direct visual language that brings to mind the neo-realist aesthetic he admires, Wall creates a dialogue between sanity and madness, clarity and miscomprehension, surface and depth. In *Boys cutting through a hedge* 2003 (fig.77), the movement, on one level, is a forceful transition from a peaceful suburbia to a cemetery. The boys are 'cutting' as in taking a

LOGS 2002 [74]
Silver gelatin print
167.6 x 209.6 (66 x 82 ½)
Edition of 4

FOREST 2001 [75]
Silver gelatin print
238.8 x 302.9 (94 x 119 ¼)
Edition of 2

taking a 'short cut' – a crooked path – rather than hacking their way through the hedge with machetes. But we could also look at the transition from one kind of consciousness to another. By climbing through a hedge, they seem to be piercing the very surface of the photograph, finding, in W.H. Auden's phrase, 'a lane to the land of the dead'. The path they take is a worn-out one: judging by the condition of the hedge and the yellowed grass, many others have made this journey, so Wall hints at how the everyday can lead to the spectral. The young men are dressed in sporty clothes and carry bags that might contain anything from booty stolen from a nearby house to schoolbooks. Either way, we experience a transition from the everyday to the otherworldly, and from youth's innocent exuberance to the levelling plain of mortality. Typically for Wall, an everyday shortcut, rather than a twilight fantasy, invited this change.

A similar transition is portrayed in *Fieldwork. Excavation of the floor of a dwelling in a former Sto:lo nation village, Greenwood Island, Hope, B.C., August, 2003, Anthony Graesch, Dept. of Anthropology, University of California at Los Angeles, working with Riley Lewis of the Sto:lo band* 2003(fig.78). Wall wanted to take a picture of archaeologists at work, and investigated a couple of sites northeast of Vancouver before setting up for three weeks at this spot at Greenwood Island, Hope, about fifty kilometres east of the city. The buckets are tools of the archaeologist's trade, just as their bright orange colour, complementary to the earthy greens of the cedars and ferns, is a tool of the artist's trade. For both artist and archaeologist, they focus attention on the matter at hand, creating a surface that permits a deeper contact with the material. The sensuousness and lyricism should not let us forget that this is an example of 'near documentary' photography. He records the slow and patient excavation of history, the painstaking transition from everyday life into the land of the dead. The picture portrays a method and a goal. This method is thoughtful, careful and precise, and in that is a certain beauty; the goal is to glean knowledge about another world through a carefully composed aperture. Both reflect Wall's ambition as an artist. Archaeologist and artist create a small square that contains countless metonyms of human consciousness, a beautiful surface and a frame through which we might unearth a few genuine fragments of human life.

With *Burrow* 2004 (fig.76), we are presented with another hole in the ground, but this one is impenetrably black. As he often does, Wall set out on a casual, exploratory bike trip with one of his assistants and they happened across this landscape; its combination of an everyday scene and a black square of incalculability makes it seem ready made for a Jeff Wall photograph. The 'black square' inevitably brings Malevich to mind; he famously painted a black square to create an emblem of Suprematism, which sought to rediscover a 'pure art' that had become 'obscured by the accumulation of "things"'. But Wall is manifestly interested in 'things'; he pointed out to me that the object near the entrance to the burrow is a manicure kit, a little device for cleaning and purifying one of the body's most visible parts. The detail creates a witty counterpoint to an image that shows us a hovel that may have been built, like the Invisible Man's room, to keep the hostility of the external world at bay, while the picture also quotes the desire for 'pure feeling' that characterised modernist abstraction. Someone has probably lived within this 'black square', and that person may have found a kind of peace or meaningful existence there, however provisional. We will never know, exactly, what happens within this invisible world, but we feel or imagine it through the picture.

'As I get older', comments Wall, 'I'm more interested in what is made invisible in the experience of the picture. This isn't easy to explain or describe; it's a feeling, a feeling that the picture doesn't just display its contents to the eye. It also leaves something undisclosed, something that cannot be seen in the viewing of the world but can be experienced or sensed – sensed as unseen.' The invisible, boarded-up world of *Blind window no.1, Burrow* or *Fieldwork* recognises the uncontrollable, contingent element in any photograph, and it is also a way of acknowledging the subjectivity of his audience. In fact, the two are intimately interlinked. In *Overpass, Forest, Boys cutting through a hedge* and *Rainfilled suitcase,* we have a rich, detailed depiction of an everyday scene suggestive of his subjects' – or anybody's – inner life, which is a counterpart to the unseen and the spectral. Wall captures, invisible on the surface of the picture, the chimeras – those ineluctable lumps of subjectivity that never let go – that haunt the everyday. The protagonist in Wall's *Invisible Man* had to turn his world inside out in order to give form to his life. Wall's method of turning the world of photographic depiction inside out leaves something unseen. And an enormous part of the pleasure of looking at his photographs is to imagine, ferocious chimera in tow, what we might find within the invisible.

BOYS CUTTING THROUGH A HEDGE
2003 [77]
Transparency in lightbox
204 x 259.8 (80 3/8 x 102 1/4)
Edition of 2

FIELDWORK. EXCAVATION OF THE
FLOOR OF A DWELLING IN A FORMER
STO:LO NATION VILLAGE,
GREENWOOD ISLAND, HOPE, B.C.,
AUGUST, 2003, ANTHONY GRAESCH
DEPARTMENT OF ANTHROPOLOGY,
UNIVERSITY OF CALIFORNIA AT LOS
ANGELES, WORKING WITH RILEY
LEWIS OF THE STO:LO BAND 2003
[78]
Transparency in lightbox
219.5 x 283.5 (86 3/8 x 111 5/8)
Edition of 2

Making *The Flooded Grave* was an exceedingly complex process, involving outdoor photography, the capturing of sea creatures, studio photography and computer montage. The grave in the foreground was photographed in one cemetery and digitally conjoined with the background landscape shot in another. After the grave was dug, Wall and his assistants made a cast of the hole that was then set up in the artist's studio. A seabed, characteristic of the North Pacific, was mocked up in this cast, and the underwater scene was created and photographed in the studio before being integrated, as a computer montage, into the rest of the photograph. Altogether, the process took almost two years.

The Flooded Grave depicts someone's split-second hallucination during a cemetery visit and in this respect the picture is related to *Dead Troops Talk*. Thematically, the photograph is also linked to works such as *Fieldwork, Burrow, Boys cutting through a hedge* and even *Rainfilled suitcase.* The square aperture acts both as a 'lane to the land of the dead' and to give a hint of photography's 'liquid intelligence'. The scene within the grave – anemones, fish, crabs, starfish, sea urchins and an octopus – is a typical slice of life from the sea bottom near Vancouver. Above ground, the everyday events form the plausible surface of the photograph, and the seabed hallucination is a glimpse into another reality. The two are conjoined, and interact both sensuously – the purples and reds of the grave offset by the greens and blues above ground – and intellectually. Typically for Wall, a sensual, pleasurable surface is an invitation to reflect, and the spectral and the mundane exist in the same pictorial space.

CRAIG BURNETT: What strikes me about this picture is that everything in the cemetery, from the hoses to the trees to the crows, looks animated, as if each thing, alive or dead, had a kind of personality.

JEFF WALL: *That's a good way of looking at it. I wanted each of the elements to be as important as the other. People tend just to look into the water, but the essence of the picture is the composition, even more than the undersea part: the relation of the green tarp to the rectangle of the hole and the earth mound and the blue hose on the right and the other hose coming down, and the crows and the guys in the back, and so on. That's what I like about the picture, and that's the really pleasurable part. I carried that feeling into the undersea part, so it's all of a piece. You're right – it's not just one lively area, it's not one part that's alive; it's all alive.*

CB: And how much of this aliveness was achieved using computer montage? Did you add the crows, for example?

JW: *That's what it really looks like at Mountain View Cemetery. The crows are always hanging around there. Nothing is invented; that's what you would see on a rainy day.*

CB: Why did you include the men in the background?

JW: *They're coming to pump out the hole, so the water's not going to be there long. I thought it was interesting that not only would the vision of the undersea area last only an instant, the whole situation would likely change after a few minutes. It's important to me in a big picture with a stable composition that on one level it seems like it will last forever, while on another you realise that it's a photograph and therefore represents an instant, and in the next instant it's going to change. I like to hint at that because the stability of the composition often obscures that sense that it's a photograph and so you think that this moment will last forever. I like that, but I also like to work against it. When those guys come down, and turn that pump on, that water's going.*

CB: And the hoses? They have an almost sinister presence, like a snake in a Poussin painting.

JW: *The men are pumping out flooded holes all the time when its rainy, so there are always hoses snaking about. They are an important part of that 'aliveness' you were talking about. And just to come back to that, the idea is that there's 'aliveness' everywhere in the picture is important, but that aliveness is caused by the picture. That is, I feel that it is the presence of a picture of those things, the hoses, the hole, etc., that discloses that aliveness. This isn't to say one couldn't recognize that while actually visiting the place and having what would then be an aesthetic experience on the spot. That obviously can happen and does happen. But that makes the direct experience akin to the experience of a picture. As I said, I think*

THE FLOODED GRAVE 1998–2000 [79]
Transparency in lightbox
228.6 x 282 (90 x 111)
Edition of 2

that sense of the overall vision of the place, including the imaginary part, but not dominated by it, is the most important or best aspect of the picture, far more important than the theme. The theme is only an allegory for the picture itself, in the sense that every subject just says, 'I'm an instance of a picture'. I think themes are important, but not the essential thing; you can make great pictures from the dumbest possible theme. I mean, I think the theme of Flooded Grave is nothing special.

CB: 'Life goes on', 'In death there's also life', etc?

JW: *Exactly, it's like a Sunday morning sermon. But I thought the banality was something to overcome.*

CB: But for most people, the underwater world is too surreal to be banal. Besides, this particular undersea view is a very local experience – it's like looking into a Pacific tidal pool.

JW: *It's very local. I worked with oceanographers to create a momentary fragment of a real undersea corner. I didn't want an aquarium display, a cross-section of sea life from the area, or anything like that. I wanted it to be a snapshot of everyday life at a certain depth of sea water.*

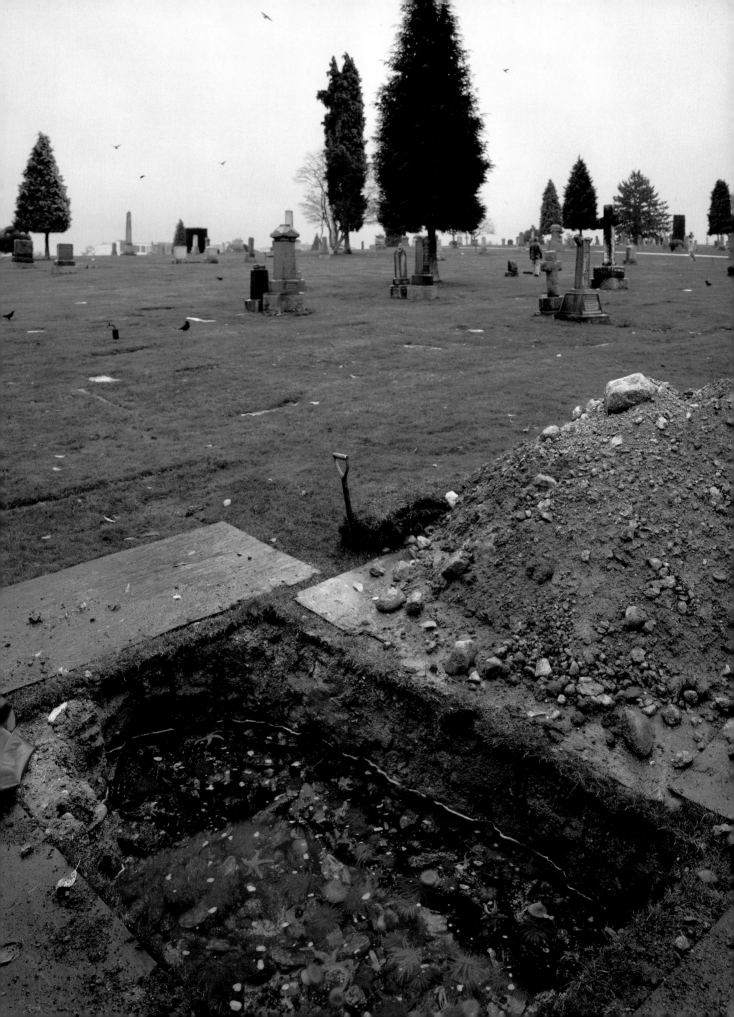

'Pictures are bits of life,' I said. 'We paint life as we see it. For instance, Charley, you are coming along the trail. It is night. You see a cabin. The window is lighted. You look through the window for one second, or for two seconds, you see something, and you go on your way. You saw maybe a man writing a letter. You saw something without beginning or end. Nothing happened. Yet it was a bit of life you saw. You remember it afterward. It is like a picture in your memory. The window is the frame of the picture.'
Jack London, *The Sun-Dog Trail* (1905)

The marriage of pictures and windows is one of the more fruitful institutions of aesthetic theory. Jeff Wall is among their many offspring. He was looking out of a bus window, perhaps through the spectral reflection of his face, when he saw the back-lit advertisement that sparked his artistic vision. To this day, he likes to drive around Vancouver, searching through his windshield for new pictures. 'A different kind of picture is a different way of experiencing the world,' he comments, 'a different world almost'. He first looked into these 'different worlds' as a teenager enthralled by art, and then as an art-history student, encountering the great pictures of the Western tradition as projected slides – little worlds that offered visual pleasure and lush conundrums, all illuminated like the late-night windows of an apartment block. As in many love affairs, Wall's relationship with his predecessors – Old Masters, filmmakers, photographers – began with admiration and longing before eventually bearing fruit.

At least since the Renaissance painter and theorist Alberti advised artists in his treatise *On Painting* to recreate the visual world as if looking through a window, that humdrum piece of architecture has proved a persistent metaphor for pictures. Velázquez's *Las Meninas* 1656, the so-called 'theology of painting',

is made up of a series of pictures within pictures, created by mirrors, doorways and windows. Manet, among many other nineteenth-century artists, often painted from his window, and paintings such as *The Balcony* 1867 use architectural elements as frames for pictures within pictures. Magritte parodied the age-old relationship between pictures and windows with *The Human Condition* 1935, a painting of an easel-bound painting in front of a window that seamlessly recreates the landscape outside. Wall exhibited *The Destroyed Room*, his first light box, in the window of a gallery, and its subject was partly suggested by a window display. Manet, coincidentally, exhibited *Nana* 1877 in a department store window after the salon had rejected it. Street photographers Robert Frank and Garry Winogrand took countless photographs from behind the windshields of their cars.

The list of anecdotal evidence is theoretically endless. We know that windows, and therefore pictures, mediate the world and its representation, public space and private life, and also provide a frame for artists to compose and display beautiful things. But windows, for some artists, have also marked the threshold between the real and the ideal. In Mallarmé's beautiful poem 'The Windows', the Symbolist contrasts the hospital in which the speaker is incarcerated – with its sickness, faeces and death – with the window through which he gazes, where, 'In the chaste morning of the Infinite, / I look at myself and see myself as an angel!' Although the window seems to offer an escape from everyday pain and mortality, a brief visit to a transcendent world where beauty flourishes, Mallarmé concludes that 'the Here-below is master'. Yet he still glimpses through a pane of glass some kind of heaven, with the poet installed as its resident angel.

BLIND WINDOW NO.2 2000 [80]
Transparency in lightbox
134 x 170.5 (52 3/4 x 67 1/8)
Edition of 5

A VIEW FROM AN APARTMENT
2004–5 [81]
Transparency in lightbox
167 x 244 (65 3/4 x 95 5/8)
Edition of 2

In *A view from an apartment* 2004–5 (fig.81), Wall taps into the vast metaphoric potential of windows, but for the most part he puts aside questions about the nature of the real, the line between public and private life and the possibility of transcendence. Instead, he asks – and this question is one of his chief muses – what makes a good picture? Two young women occupy a room surrounded by domestic things and a proliferation of windows, frames and pictures. The atmosphere suggests a relaxing Saturday afternoon, with nothing pressing to do but a few household chores and some reading of magazines. The title tells us that the picture is about the 'view' – but which view? There are countless pictures within the photograph: the largest one is through the main window, offering a view of trees, some about to burst into pink blossom, a few industrial buildings, the Burrard Inlet, the Vancouver harbour and the buildings of the city centre. In the smaller section of the window on the left, we have another scene: a fragment of an evergreen tree, a patch of hazy pink, and a number of power lines that intersect the image (creating more pictures within pictures). Further still to the left, through the little window, we can see more of the tree, a road and a car. Each picture is a fragment – or synecdoche – of a broader vista, yet the overall picture remains unseen, and will forever remain so.

Yet more pictures lurk in the apartment. On the television screen is the faint reflection of another unseen window and several objects that are in the room and behind the woman reading: orchids, a table and, framed by the window, the coastal mountains, like the ones in *Coastal Motifs*. The remote control rests nearby, implying that a whole world of pictures might illuminate the apartment at any moment. Behind the standing woman, reflected in the glass of a picture within a black frame, is a tiny still life: a tap

and sink, an indistinct picture of the kitchen, otherwise occluded by the wall. The water bottle on the floor, a synecdoche of the finger of the Pacific Ocean outside, reflects the sky, as does the teapot on the table. Beside the bottle, a snapshot rests on the floor. Everywhere there are windows and glass surfaces, everywhere pictures, suggesting a reality as fluid and multifaceted as the almost infinite number of objects that reflect the world or create frames through which to view it. So what is the 'view from the apartment', the real picture? Every tiny reflection or framed corner is a 'bit of life' snatched from an incalculable whole. *A view from an apartment* presents a vivid argument for the pleasure of looking closely at things and against our impulse to replace visual experience with a tidy, logical summary in words. Discussing *The Storyteller*, Wall says that 'when you really *look* at the world, conceptual oppositions collapse'. Daily life is, of course, built upon conceptual oppositions. But when they collapse, our impulse to get the 'big picture' is suspended in that moment of pleasure.

In *A view from an apartment*, the woman on the left is caught mid-stride; from that we know that the picture is merely a visual fragment torn from an endless narrative of intertwining stories. This relationship between pictures and stories is explored in Jack London's short story *The Sun-Dog Trail* (1905). Two men – one of European descent, the other Native American – end up in a cabin on the Alaskan trail, smoking pipes and looking at a cluster of pictures that a previous denizen had pinned to the walls. Charley, the native man, is puzzled by pictures because he feels that they are frozen things, without the sequence of events that characterises life. In one painting, for instance, a man is shot, so according to Charley the picture is 'all ending'. Because he comes from an oral,

A PARTIAL ACCOUNT (OF EVENTS TAKING PLACE BETWEEN THE HOURS OF 9:35AM AND 3:22PM, TUESDAY 21 JANUARY 1997) 1997 [82]
Transparencies in lightboxes
Each 55.7 x 402.2 (21 7/8 x 158 3/8)
Edition of 2

storytelling tradition, he expects a full narrative, with characters, motivations and causal relationships. The other man, who happens to be an amateur painter, feels compelled to explain 'the wisdom of pictures'. Eventually, he offers the somewhat traditional definition – pictures are 'bits of life' glimpsed through windows – that opens this chapter.

The painter's description sounds uncannily similar to how Wall might describe the conception of one of his photographs: *You saw something without beginning or end. Nothing happened.* Even while Wall's pictures are often tantalisingly suggestive of narrative, *they are without beginning or end.* And although Jack London is scarcely an influential art theorist, he knows how to tell a toe-curling tale, which he does through Charley, who, after getting his brief lesson in aesthetics, regales the painter with a tale of a dog-sled chase through the Alaskan wilderness that features abandoned cabins, biting cold, near starvation and, finally, an on-the-knees duel to the death. The storyteller puts something together as a series of fragmentary, remarkable pictures, and the death provides the final frame. His narrative is a story within a story, a picture within a picture, and another way of framing the infinite, overlapping narrative of the world. Charley and his painter friend conclude that they both strive to depict unresolved experience with pictures that are 'bits of life'. This is also the wisdom of pictures such as *Blind window no.2* (fig.80) or *A view from an apartment*: they demand that we look closely without trying to replace visual experience with an explanatory tale. In Wall's *A Partial Account (of events taking place between the hours of 9:35am and 3:22pm, Tuesday, 21 January 1997)* 1997 (fig.82), a strip of street photographs seems to tell a story, but it is always 'a partial account'. Some of the pictures are so overexposed that we are invited to project our own image onto the blank slate. His photographs are always this 'partial account', and, like poems, they give the viewer pleasure through lyrical and sensual richness, metaphor and ambiguity.

The double photograph *Man in Street* 1995 (fig.83) teeters on its ambiguity. At first glance, it seems to invite the viewer to make a choice: on the left side, the blood-bespattered man looks like a fiendish aggressor, while on the right he might be the dazed victim of an attack. Our first impulse is to judge – to put someone on trial for a vicious deed that preceded the event of the photograph. Yet the double nature of the picture creates a self-cancelling whole, derailing that same impulse. Look again and the 'either/or' interpretation fails to contend fully with all the possibilities presented by the sum of the two pictures. On the left side, the letters 'XO' decorate the bench. Probably a fragment of an ad, the letters may represent little more than a visual scrap of the urban environment, but they also illustrate the false choice presented by the picture. 'XO' suggests that we should choose between two options, but we know by now that Wall prefers 'the crooked path'. The picture leads us into a paradox, only to undo its own neatness. Perhaps the man on the street is a gloating sadist or a hapless scapegoat, perhaps neither. The oxymoronic structure of the picture prevents us from judging the situation *at all*. He is forever both victim and thug, forever a conundrum. *Man in Street* tells us that it is impossible to know everything, and yet it is still up to us to look closely and evaluate the picture. Because we can never fully comprehend the 'big picture' – everything that preceded or follows the moment of the photograph – we have to suspend our moral judgment and activate, instead, our aesthetic judgment.

In Franz Kafka's novel *The Trial* (1925), windows

MAN IN STREET 1995 [83]
2 transparencies in 1 lightbox
Each 54 x 66 (21 1/4 x 26)
Edition of 4

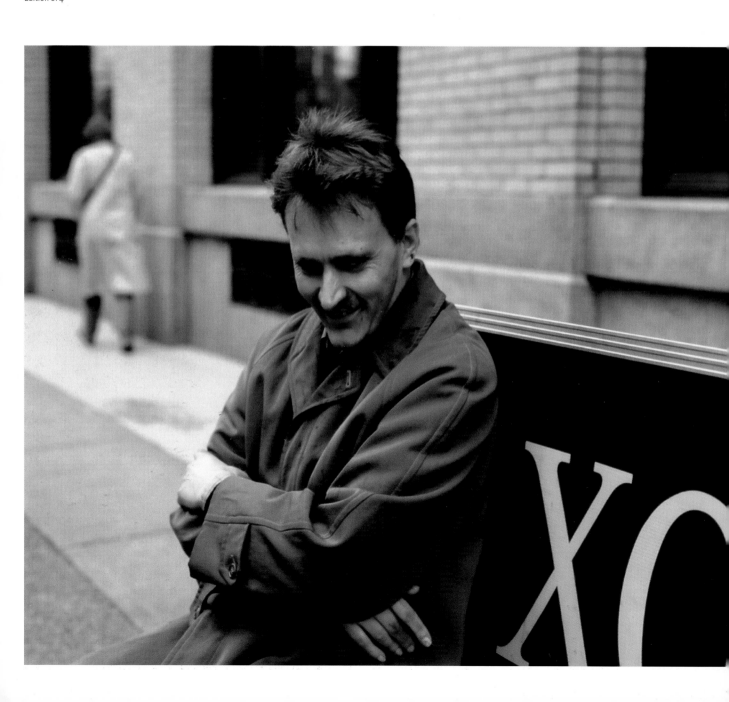

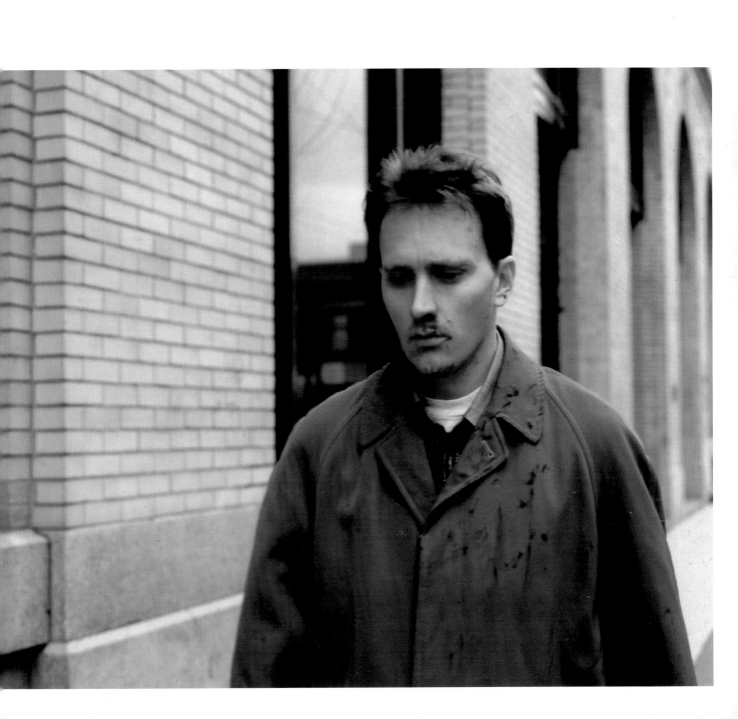

provide escapes, or diversions, from the inscrutable trial that besets K., the protagonist. K. is subjected to a sudden, irrational arrest, and ends up looking for the 'court' to which he has been mysteriously summoned amid crowded suburban tenements. While scanning the houses for signs of the court, he sees, in the windows, men talking, women's heads popping up behind piles of bedding, and he hears a brief snippet of laughter. The experience of looking into these little window-worlds seems to suspend, briefly, the relentless anxiety of the trial, and even reduces the absurd sense of urgency that caused him to rush, unforced, to his destination. Finally, as the novel ends and he is about to be killed in a quarry on a moonlit night, a 'casement window flew open, like a light flicking on, a human figure, faint and insubstantial at that distance and height, leant abruptly forward and stretched both arms out still further'. The window, and its angelic occupant, seems to offer his last stab at freedom. Nothing happens, of course – K. is killed. The window, none the less, is an earthbound version of Mallarmé's: it offered a momentary glimpse of everyday beauty free from the trial that leads inexorably to his death.

Among many other things, Wall's photographs act like Kafka's windows – glimpses of an imagined world where the trial of life is put on hold. Yet a good picture does not flinch in the face of ugliness or violence. It succeeds whether it depicts madness, sanity or just a patch of subtle, unrecognised beauty – the subject matter of three relatively recent photographs that rank amongst Wall's best: *A man with a rifle* 2000 (fig.86), *A woman with a covered tray* 2003 (fig.85) and *Dawn* 2001 (fig.88). Together, *A man with a rifle* and *A woman with a covered tray* portray two poles of human behaviour. *A man with a rifle* depicts a paroxysm of pointed anger. What is he aiming at? It

might be the tree, which has a kind of looming, monstrous presence, or the parking meter, which seems to come to life as a big-eyed android, or the gaping emptiness between them, which he fills with the impotent rounds of an invisible gun. In *A woman with a covered tray*, the subject enters a landscape of dense greenery as if delivering a precious gift. She wears a hairnet and her trousers look like part of a uniform, so she may be a nurse or a caterer. Although her delivery of food or medicine is probably an act determined by her vocation, it comes across as a spontaneous act of virtue. The red berries on the bush to her left, glowing with preternatural brilliance, and the Rousseau-like lushness of the foliage, hint at the generosity of her action. The rifleman, by contrast, serves up death against a desolate backdrop. The tyre on the truck is labelled 'wilderness', though the gritty urban setting is anything but. He casts a vivid shadow, which seems to aim at a sign across the street that reads 'ALMOST EVERYTHING'. He is gripped by a fantasy of power, and his shade aims to eliminate 'almost everything' but his subjectivity. That way, one imagines, the world would be rendered comprehensible.

The rifleman's gesture is one of solipsistic fantasy. Goya's *The Madhouse* (fig.87), stuffed with the judged and accused of the world, features a figure, central to the composition, poised in a remarkably similar attitude to Wall's rifleman. Naked, vulnerable, and seemingly alone despite occupying an asylum teeming with raucous inmates, he aims at some invisible chimera. All the inhabitants of the madhouse are incarcerated and helpless, yet most are delirious with fantasies of power. *A woman with a covered tray*, on the other hand, brings to mind Poussin's *Landscape with the Ashes of Phocion* (fig.84), a painting that illustrates a story reminiscent

Nicolas Poussin
LANDSCAPE WITH THE ASHES OF
PHOCION 1648 [84]
Oil on canvas
116.5 x 178.5 (45 7/8 x 70 1/4)
National Museums Liverpool
(Walker Art Gallery)

A WOMAN WITH A COVERED TRAY
2003 [85]
Transparency in lightbox
164 x 208.6 (64 5/8 x 82 1/8)
Edition of 2

A MAN WITH A RIFLE 2000 [86]
Transparency in lightbox
226 x 289 (89 x 113 3/4)
Edition of 2

of Kafka's trial. Phocion has been falsely accused of treason and put on trial by the people of Athens. He is executed, burned and his remains exiled; the picture shows his widow collecting his ashes in order to return them to Athens. In both Wall's and Poussin's pictures, a woman prepares to deliver virtue or justice – and her action is sustained by a landscape that is distinct from the frozen institutions signified by the background architecture. The resemblance of Wall's works to these two earlier pictures may be coincidental or something may be bubbling up in his art-historical memory. Either way, while we can never know the story behind the two pictures, their dialogue with the art of the past creates a window through which to understand Wall's depiction of modern life. The man with a rifle may be light-heartedly dramatising a past experience or imitating an event he has witnessed and the woman may have a weapon on her covered tray, but their resemblance to the art of the past suggests otherwise.

Visually compelling, reluctant to reveal all their secrets, thematically complex and touched by allusions to Old Master painting, *A woman with a covered tray* and *A man with a rifle* show Wall at his cinematographic best. Documentary photography, however, is equally important to him, and *Dawn* 2001 (fig.88) is a supreme piece of street poetry. The mesmerising presence in *Dawn* is the large stone on the sidewalk, which hunkers in the lilac light of dawn like a strange excrescence of the natural world in a rough and ephemeral corner of the city. Wall noticed this corner while shooting *Overpass* nearby, catching a glimpse of the scene from behind the window of his car. The light, the intertwining telephone wires and poles, the arrangement of colours – all of these elements contribute to the subtle beauty of the scene. But the way in which the central telephone pole meets and seems to fuse with the stone suggests a collaged image of an upside-down streetlamp. The kerb, as well, curves in a line to join the stone, creating another likeness of the streetlamps that stipple the background in pinkish blobs, all aglow with the last glimmer of light before they turn in, like Vampires, at dawn. On the billboard in the background is an advertisement for a Harry Potter film, an aperture into another world and a reminder of the steadfast popularity of fantasy. *Dawn* is Wall's take on Mallarmé's 'chaste morning of the Infinite'. His response to art's persistent yearning for transcendence is this picture of an extraordinary corner of the modern world. The internal rhymes triggered by the stone replace this yearning with beauty that is immanent and revelations that arise from the process of looking closely and repeatedly. The big stone, besmirched by words and yet none the wiser for all it has witnessed, is a light that will remain forever mute.

Francisco de Goya
THE MADHOUSE 1812–14 [87]
Oil on canvas
45 × 72 (17 3/4 × 28 3/8)
Real Academía de Bellas Artes de San Fernando, Madrid

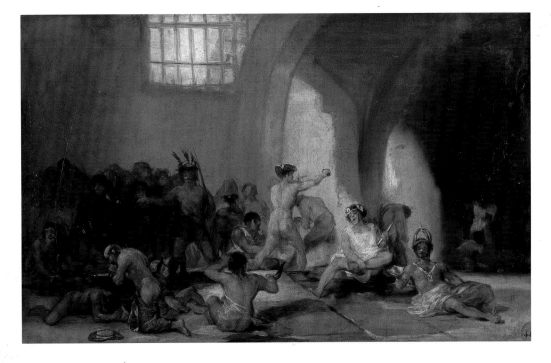

DAWN 2001 [88]
Transparency in lightbox
230 x 293 (89 3/4 x 115)
Edition of 2

Biography

1946	Born in Vancouver, B.C., Canada
1968–73	Postgraduate studies in art history, Vancouver and London, England
1976	Begins colour photography
1974–99	Professorships in art in Canadian art schools and universities
1985	Begins publishing critical essays
1991	Begins digital montage
1995	Begins black and white photography

Selected Solo Exhibitions

1978	Nova Gallery, Vancouver
1979	*Faking Death* 1977, *The Destroyed Room* 1978, *Young Workers* 1978, *Picture for Women* 1979, The Art Gallery of Greater Vancouver
1983	The Renaissance Society, University of Chicago
1984	*Jeff Wall: Transparencies,* Institute of Contemporary Arts, London; Kunsthalle, Basel
1987	*Young Workers,* Museum für Gegenwartskunst, Basel
1988	Le Nouveau Musée, Villeurbanne Westfalischer Kunstverein, Münster
1989	Marian Goodman Gallery, New York
1989–90	*The Children's Pavilion* (a collaborative project with Dan Graham), Marian Goodman Gallery, New York; Galerie Roger Pailhas, Marseilles; Fonds

Regional d'Art Contemporain, Rhône Alpes, Lyons; Galerie Chantal Boulanger, Montreal; Santa Barbara Contemporary Arts Forum

1990	*Jeff Wall 1990,* Vancouver Art Gallery; Art Gallery of Ontario, Toronto The Carnegie Museum of Art, Pittsburgh, Pennsylvania
1991	San Diego Museum of Contemporary Art
1992	Louisiana Museum, Humlebaek, Denmark Marian Goodman Gallery, New York Palais des Beaux-Arts, Brussels
1993	Kunstmuseum Luzern, Lucerne; Irish Museum of Modern Art, Dublin Fondation Cartier pour l'art contemporain, Jouy-en-Josas, France *The Childrens' Pavilion* (a collaborative project with Dan Graham), Museum Boymans-van Beuningen, Rotterdam
1994	Museo Nacional Centro de Arte, Reina Sofia, Madrid Neue Gesellschaft für Bildende Kunst Galerie, Berlin Galerie Rüdiger Schöttle, Munich Deichtorhallen, Hamburg De Pont Foundation for Contemporary Art, Tilburg, The Netherlands Stüdtische Kunsthalle, Düsseldorf
1995	Marian Goodman Gallery, New York Museum of Contemporary Art, Chicago Jeu de Paume, Paris
1996	Museum of Contemporary Art, Helsinki *Jeff Wall: Landscapes,* Kunstmuseum Wolfsburg Stüdtische Galerie im Lenbachhaus, Munich
1997	The Museum of Contemporary Art, Los Angeles; Hirshhorn Museum and Sculpture Garden, Washington, D. C.; Art Tower Mito, Mito, Japan
1998	Marian Goodman Gallery, New York *Here and Now II: Jeff Wall,* Henry Moore Institute, Leeds *Jeff Wall: Photographs of Modern Life,* Museum für Gegenwartskunst, Basel
1999	Mies van der Rohe Foundation, Barcelona *Jeff Wall: Oeuvres 1990–1998,* Musée d'Art Contemporain, Montreal
2001	Marian Goodman Gallery, New York *Jeff Wall: Figures and Places,* Museum für Moderne Kunst Frankfurt am Main
2003	UCLA Hammer Museum, Lobby Gallery, Los Angeles *Jeff Wall: Landscapes,* Norwich Castle Museum and Art Gallery, Norwich MUMOK (Museum of Modern Art Ludwig Foundation), Vienna
2004	Marian Goodman Gallery, New York *Jeff Wall: Tableaux,* Astrup Fearnley Museet for Moderne Kunst, Oslo
2005	Schaulager, Basel Tate Modern, London

Selected Group Exhibitions

1980	*Pluralities* 1980, National Gallery of Canada, Ottawa *Cibachrome,* Photo Gallery, National Film Board of Canada, Ottawa
1981	*Westkunst: Zeitgenössische Kunst seit 1939,* Rheinhallen Messegëlande, Cologne *Directions 1981,* Hirshhorn Museum and Sculpture Garden, Washington, D.C.; Sarah Campbell Blaffer Gallery, University of Houston
1982	Documenta 7, Museum Fridericanium, Kassel
1984	*A Different Climate: Aspects of Beauty in Contemporary Art,* Kunsthalle Düsseldorf
1984–5	*Difference: On Representation and Sexuality,* New Museum of Contemporary Art, New York; The Renaissance Society, Chicago; Institute of Contemporary Art, London; The List Visual Arts Center, Massachusetts Institute of Technology, Cambridge, Massachusetts
1985	*Rodney Graham, Ken Lum, Jeff Wall, Ian Wallace,* 49th Parallel Center for Contemporary Canadian Art, New York *Visual Facts: Photography and Video by Eight Artists in Canada,* Third Eye Centre, Glasgow; Graves Art Gallery, Sheffield; Canada House Cultural Centre Gallery, London *La Nouvelle Biennale de Paris,* Grand Halle du Parc de la Villette, Paris *Aurora Borealis,* Centre International d'Art Contemporain de Montréal *Günther Förg and Jeff Wall: Photoworks,* Stedelijk Museum, Amsterdam *Cover/Doppelgünger,* Aorta, Amsterdam
1986	*Making History: Recent Art of the Pacific West,* Vancouver Art Gallery, Vancouver *Prospect 86,* Frankfurter Kunstverein and Schirn Kunsthalle, Frankfurt *Focus: Kanadische Kunst 1960–85,* Art Cologne, Rheinhallen Messegelünd, Cologne Or Gallery, Vancouver
1987	*L'Epoque, la mode, la morale, la passion: Aspects de l'art d'aujourd'hui, 1977–1987,* Musée National d'Art Moderne, Centre Georges Pompidou, Paris